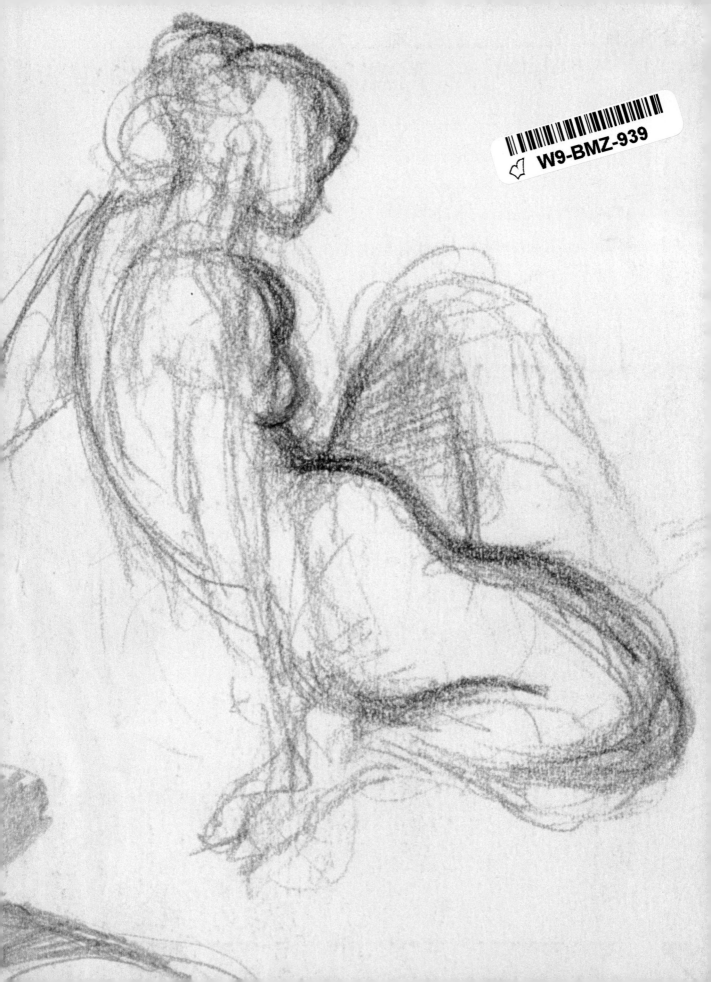

W9-BMZ-939

The Painter's Corner

THE HUMAN FIGURE

BARRON'S

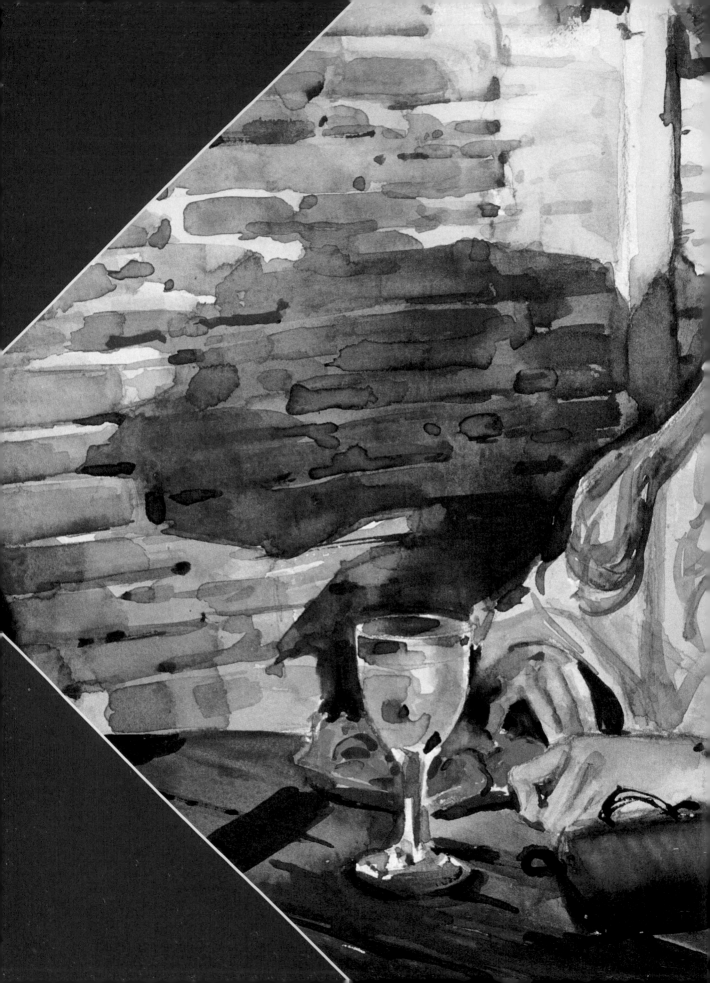

THE HUMAN FIGURE

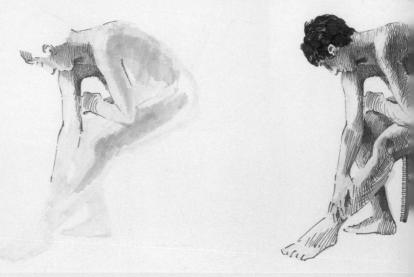

© Copyright 2004 of English language translation by
Barron's Educational Series, Inc., for the United States,
its territories and possessions, and Canada.

Original title of the book in Spanish: *El Rincon del Pintor:
Figura*
© Copyright PARRAMON EDICIONES, S.A., 2003
Published by Parramón Ediciones, S.A., Barcelona, Spain

Author: Parramón's Editorial Team
Editor in Chief: Mª Fernanda Canal
Editor: Tomàs Ubach
Editorial Assistant and Image Archives: Mª Carmen Ramos
and Núria Barba
Text and Coordination: David Sanmiguel
Exercises: Vicenç Ballestar, Mercedes Gaspar,
Óscar Sanchis, and David Sanmiguel
Photography: Nos & Soto

Translation from the Spanish: Michael Brunelle and
Beatriz Cortabarria

All rights reserved. No part of this book may be reproduced
in any form, by photostat, microfilm, xerography, or any
other means, or incorporated into any information retrieval
system, electronic or mechanical, without the written
permission of the copyright owner.

All inquiries should be addressed to:
Barron's Educational Series, Inc.
250 Wireless Boulevard
Hauppauge, New York 11788
http://www.barronseduc.com

International Standard Book No. 0-7641-5606-3

Library of Congress Catalog Card No. 2003113112

Printed in Spain
9 8 7 6 5 4 3 2 1

Acknowledgments:
Parramón Ediciones, S.A. wishes to thank Elena Marigó and Nina
Soto for their collaboration in this book.

Contents

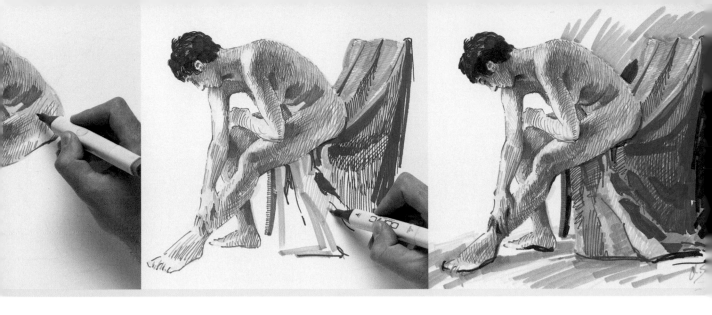

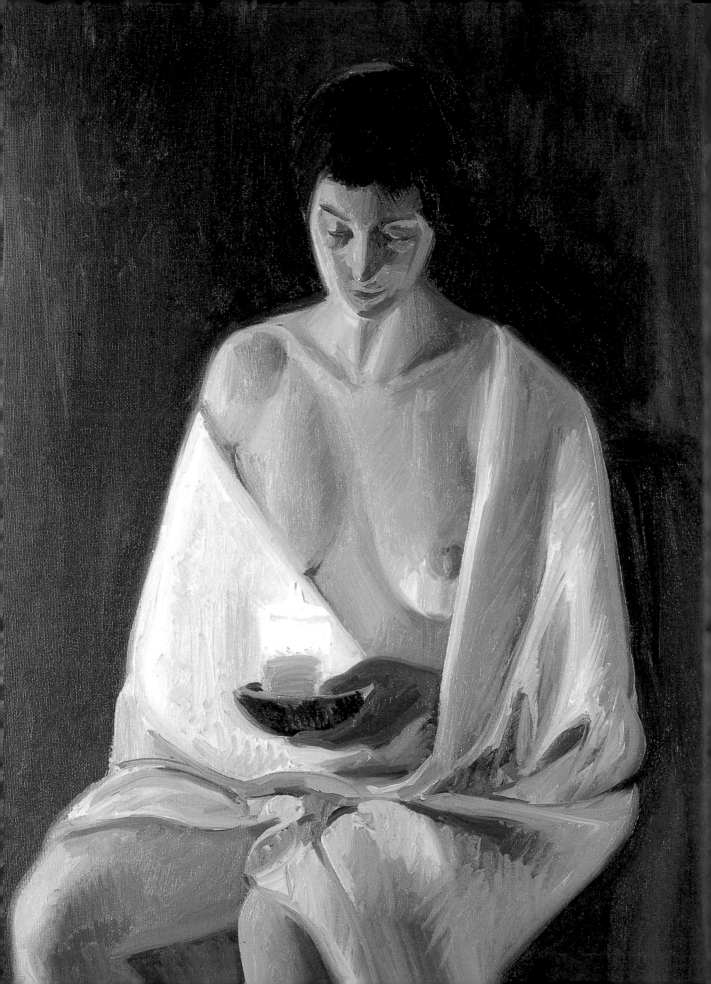

Introduction

The representation of the human figure is the central and most important subject in the learning process of an artist. In art school, once the students are able to handle the drawing and painting tools and know the basics of drawing and composition, they go on to study the human figure. The human body is not just another shape; it contains information about the nature of people, and the artist expresses it, consciously or unconsciously, according to his or her own interpretation. The artist shares those ideas with other artists, and thus each period incorporates a new set of concepts. This is how figure drawing and painting has changed through time, according to the rhythm of the changes in style and thinking. However, it is not the intention of this book to solve such complex matters but to provide practical resources for mastering figure drawing and painting, from basic concepts about anatomy to detailed information on how the human body moves.

The different sections of this book cover the most appropriate techniques and procedures to complete any figure drawing or painting project, paying special attention to practical aspects, which are fully illustrated and explained in detail in numerous exercises.

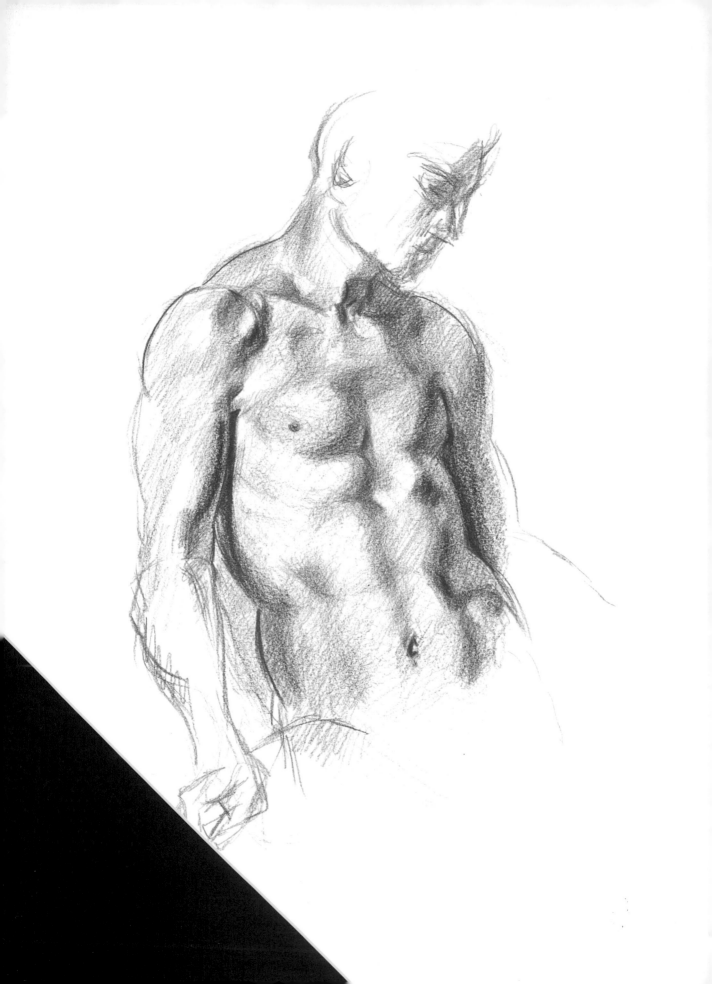

The Human Figure in Art

To speak of the human figure is to speak of the history of art, because this is the only subject matter that has been depicted in every style, time period, and country.

The human body has always been used as a model for painting and drawing. But the significance and meaning of all works of art are not the same by any means. This chapter talks about some of the esthetic intentions behind works of art that can be admired in museums.

◆

The human figure has always held a particular significance. Changes in style also meant changes in that significance.

◆

their backs on old techniques because they did not think that they answered their question about human beings—the oldest question and also the newest one, the most important one.

When an artist chooses to paint a nude, it may be to show off his or her technique, or simply to practice the craft in order to improve it. Artists may not always be aware that figure painting is the oldest genre, and that its meaning is related more to the image that people have of themselves than to reality. The same can be said of portraits and of mythological, religious, and allegorical themes. In art, the human figure has always held a particular significance, and the changes in style have also brought changes in that meaning. This chapter includes examples of some works of art that explicitly illustrate the importance of the human body in different periods. During these periods some new genres were born and others fell out of use. Some painters turned

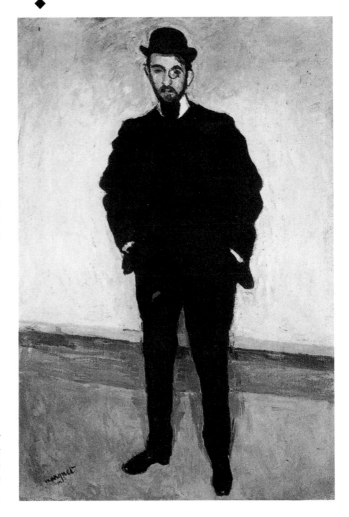

Albert Marquet, André Rauvyce. Musée d'Orsay (Paris, France). Figure painting is the most popular artistic subject. Realistic portraits like this one are only one of the many artistic options offered by the genre.

Egyptian mural depicting a Nubian dancer, c. 1420 B.C. Tomb of Horemheb (Thebes, Egypt). Although this stylized figure fulfills a decorative purpose, it expresses the essence of the dance even better than a realist painting would. In this instance, the human body is a vehicle for rituals.

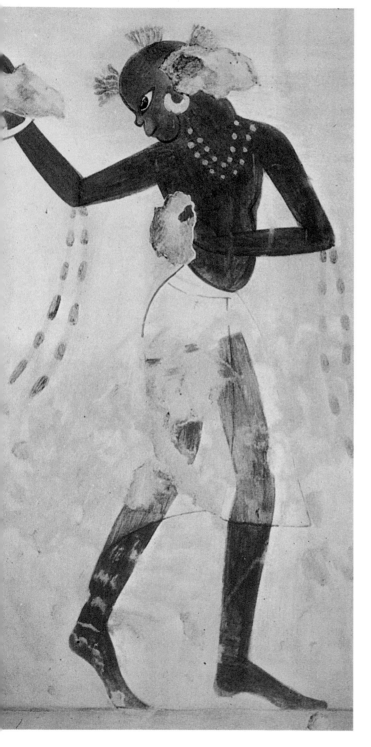

Human Figure and Human Body

The main artistic concept of any figure painting is the representation of the human body, a body that does not depict any particular person but represents the general idea of man or woman. The different ideas and concepts that people had of it mark the evolution of styles. For example, the Greek concept of the human body was very different (opposite in many ways) from the medieval one, and it differed as well from the Renaissance concept. Logically, these ideas can be seen more clearly in nude paintings than in clothed ones.

The Importance of the Nude

The nude is, in fact, the main artistic motif in every figure painting, the one that sets the guidelines in terms of form, proportions, and expressiveness for any other subject. When a contemporary artist draws a nude, he or she is expressing, consciously or unconsciously, a general view of the human body, which goes beyond the representation of the particular individual who poses as a model. The mentality and the general artistic style of each period inevitably mark this view.

Masaccio, The Expulsion from Paradise, 1426. Brancacci Chapel in the Carmine Church (Florence, Italy). In art, nudes express a universal understanding of humans, and as such, they idealize the real anatomical characteristics of men and women.

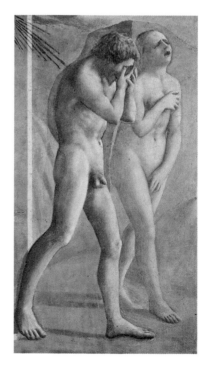

The Human Figure as a Symbol

Representations of the human figure can also symbolize certain religious beliefs, political intentions, and moral guidelines. The human body then becomes the personification of forces and values that are in conflict in mythological or sacred scenes. This is true of the entire body of work created throughout history, and the representation of specific individuals, without any other meaning, is the exception to the norm. The rich Greek and Roman mythology, and many episodes from the Bible are the two large symbolic repertoires that have inspired western artists for many centuries.

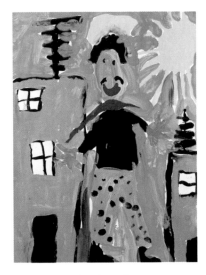

In children's drawings, figures represent a specific synthesis of the most relevant elements, those that best characterize a particular person. Fantasy and a daring attitude toward colors more than compensate for the lack of technical ability. Painting by Nina Soto.

NUDES AND MYTHOLOGY
During the Renaissance and Baroque periods, Greek and Roman mythology offered artists many opportunities to justify compositions depicting nudes. Sometimes, mythology was used as an excuse to represent the beauty of male or female bodies. But often, it was the symbolic representation (with political, religious, or moral intentions) that employed mythological themes and elements.

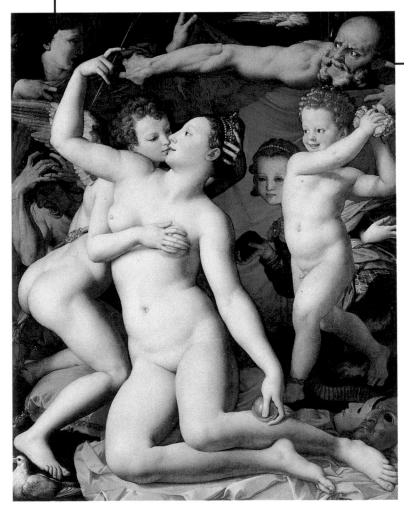

Il Bronzino, Allegory of Love, 1540. The National Gallery (London, U.K.). During the Renaissance and Baroque periods, nudes represented mythological and symbolic allegories. Each detail in this painting contains a reference to a narrative.

The Human Figure as a Portrait

In portraits, the human figure is a particular person, with his or her specific features, attire, and individual personalities. That does not mean that a portrait cannot incorporate symbolic aspects. Renaissance and Baroque portraits usually include elements and details that represent the virtue, personality, or status of the person portrayed. These details may include coats of arms, medals, flowers, animals, clothing, buildings, and so on. In fact, traditionally, portraits have not limited themselves to the representation of a particular person's features, but to a collection of allusions to their personality, which can include colors, gestures, poses, costumes, or the aforementioned accessories.

The Human Figure as an Individual

From the moment the Impressionists turned their backs on traditional mythological and allegorical themes, figure painters have created works that depict reality. The people represented in this type of scene are actual individuals who have no symbolic value other than the depiction of the specific action they perform. The artist is not inspired by text or narrative but by the everyday life that takes place in the streets, in the fields, or in the artist's own familiar surroundings. Based on this premise, some artists have produced paintings whose complexity is comparable to the great classical scenes, although they do not have the moral or mythological message that characterizes those works of art.

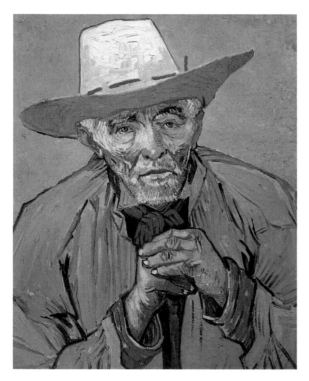

Vincent van Gogh, Portrait of Patience Escalier, *1888. Private collection. The vibrant colors of this portrait do not represent the real colors, but they express the heat of the summer and also a particular mood.*

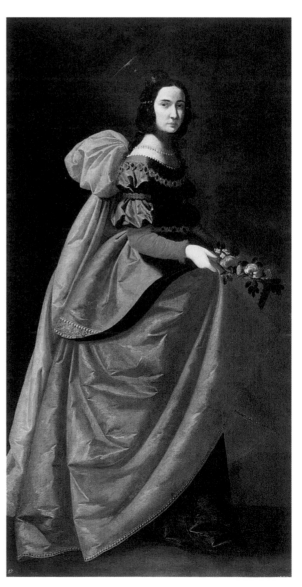

Zurbarán, Saint Casilda, *1642. Museo del Prado (Madrid, Spain). The attitude and clothing of the figure express the solemnity that must accompany the presence of a saint. In this case, Zurbarán's realism is based on a purely imaginary subject.*

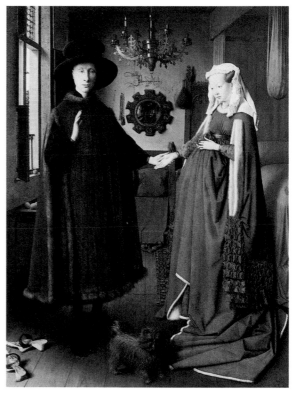

Jan van Eyck, The Arnolfini Marriage, *1434. The National Gallery (London, U.K.). The scrupulous realism of this painting incorporates a specific message conveyed through the gestures of the individuals and by the elements that surround the scene.*

CUSTOMS AND NATURALISM

Customs and naturalism are the names given to the genre containing figures, characterized by the scrupulously realistic representation of scenes of daily life. The artistic intention is essentially descriptive, and every circumstantial detail is considered objectively by the artist, and represented as is, without paying attention to any symbolic or thematic consideration.

Gustave Courbet, The Winnowers, *1840. Musée de Nantes (Nantes, France). Both the subject matter and the style of this painting correspond to a real scene that is very faithfully depicted. The figures are magnificent examples of realism.*

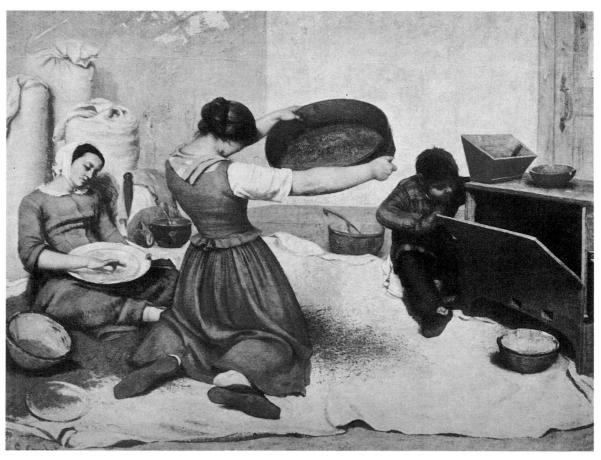

The Imaginary World

Every painting is the product of imagination, more or less removed from reality. But for some artists, working from the imagination opens the door to the creation of a fantasy in which the artist's imagination or ideals are realized, or where impossible dreams materialize, at least visually.

This applies especially to figure painting, because it is in this area that the artist's fantasy manifests itself with greater freedom and richness while creating groups, situations, and scenes.

Odilon Redon, Woman with Open Arms, *1810. Musée du Petit Palais (Paris, France). This ghostly figure is like an apparition emerging from the imagination of the artist in his desire to express enigmatic themes with an intimate content.*

SURREALISM
The Surrealist movement introduced new subject matter: the depiction of the unconscious and the free association of images. The great contribution of the Surrealists is not a form of art without logic, but the representation of a more liberal understanding of the creative process, in which there is a place for intuition. The Surrealists looked for themes in the dream world, in associations of characters and situations that occur during sleep, or that present themselves involuntarily while the artist works.

Jean-Louis Forain, Two Dancers in Front of a Curtain. *Private collection. This is a scene that maintains the ambiguity between the reality of the figures and the theatrical feeling of the background, that is, between reality and imagination.*

Caricature and Satire

One of the problems facing an artist when organizing a group of figures is that of giving each one of them a personality of their own to avoid making them undistinguishable; caricatures (more or less exaggerated) allow this. Some of the best portraits and figures of contemporary artists are on the borderline between realism and caricature. This is because a caricature is the most direct way to depict the personality and psychology of a figure. A caricature becomes a form of art when the representation maintains the same style throughout, in other words, when all the shapes that form the caricature create a coherent composition.

Satire goes hand in hand with caricature and serves as its best vehicle. However, unlike caricature, satire has a moral message and expresses the artist's belligerent attitude toward the surrounding world.

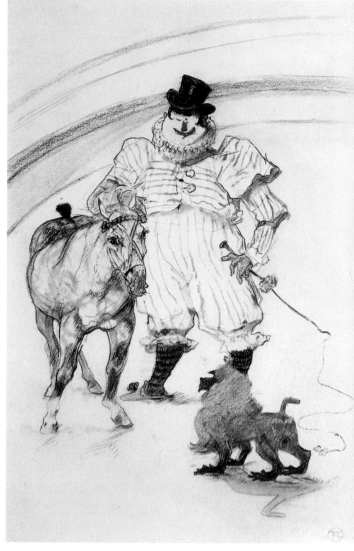

Toulouse-Lautrec, Circus Scene, *1890. Private collection. Toulouse-Lautrec uses a casual and caricature-like style to better represent the spirit of this circus number.*

PHYSICAL APPEARANCE
The art of caricature painting is invaluable in the creation of portraits. Caricatures capture the physical appearance very effectively; they define the resemblance, and then the artist needs only to exaggerate the features to achieve a convincing result.

George Grosz, Engineer Hartfield, *1920. Museum of Modern Art (New York, NY). Often, a caricature is the most direct way to capture the personality of a particular individual. The character in this painting is a vehicle for the sarcastic fantasy of the painter.*

The Human Figure as a Shape

For an artist, a figure is above all a shape with volume and color, with a particular light, and composed of parts that bend and move in specific ways. Many modern artists have looked for new techniques that are a departure from the traditional way of understanding a figure and they have distanced themselves from the conventional and moved toward extremes, approaching pure abstraction. In this type of painting, the figure is an excuse to compose a piece that is more significant for its shape and color than for its subject. It is interesting how, in many cases, the painting reaches a psychological level of expression that is as good as, if not better than, many classical portraits. This demonstrates the fundamental importance of the shape (realistic or not) in figure painting.

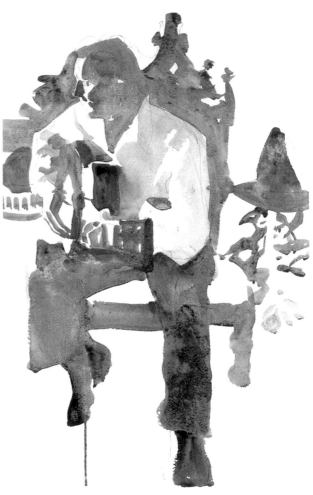

Charles Reid, John Playing the Guitar. *The shapes seem to acquire a life of their own; they simply create different relationships, which are a departure from traditional realism.*

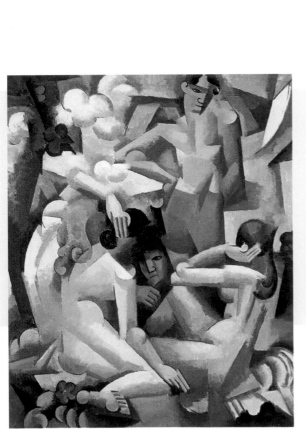

CUBISM AND ABSTRACTION

Cubist painters attempted to disintegrate real forms to reshape them later according to principles that were completely different from traditional painting. Working with color planes, some cubist portraits reconstruct the physical in surprising ways that have a psychological effectiveness. Other painters have come close to abstraction, creating a free version of nudes based on pure brushstrokes and free color interaction, which is reminiscent of the sensuality of great classical nude portraits.

Roger de la Fresnaye, Bathers. Sara Lee Collection. *The cubist figures accommodate themselves to the requirements of the painting's design: the play of planes, lines, and colors.*

Studying the Human Figure

Anatomy and proportion are always related. In practice, understanding proportion implies understanding the configuration of the body's outlines. The following pages cover both subjects.

Of all the artistic genres, the human figure is the one that has most captured the attention of artists and art experts. For a long time, it was believed that the artist was required to paint the human figure according to an idealized beauty, and that ideal could be formulated through objective rules. That conviction gave rise to certain laws that dictated the height and proportions of some beautifully constructed bodies. Contemporary artists do not follow those principles blindly, although the rules still constitute a very useful reference for depicting the figure with some confidence.

In this chapter, following a general introduction of human anatomy, all those guidelines are covered, and then there is a simple demonstration of how to draw a human body simply, with the correct overall and individual proportions.

◆

This chapter, following a general introduction of human anatomy, shows how to draw a figure simply with the correct proportions.

◆

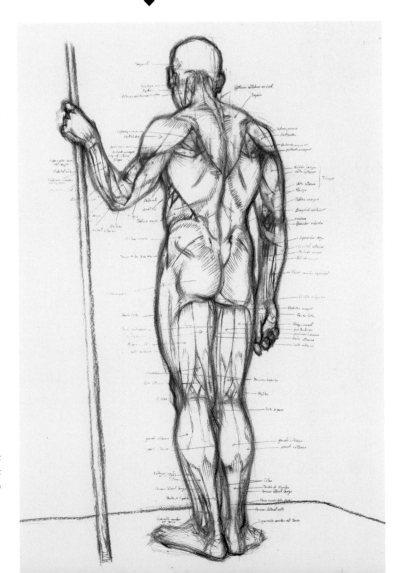

Knowledge of the human body, its anatomy, proportions, and movements, is the best ally of the artist who is devoted to figure drawing and painting.

The Proportions of the Body

A set of rules of proportions establishes the dimensions for each part of the body in such a way that the figure represented will have the correct proportions and a feeling of harmony. Our perception of human proportions is based on this idea of the balanced relationship among all the different parts of the body. The idealized classic rules dictate a height of eight heads, but reality shows that a proportion of seven and a half heads is more natural. Therefore, seven and a half heads is the size used for an adult figure and between four and six heads for children and adolescents. From all the possible patterns, this is one of the most successful for creating well-proportioned figures that are not too stylized.

GROWING AND PROPORTIONS
The proportions of the human body vary considerably through all the phases of growth. Organs develop at different rates (the head, for example, precedes the rest of the anatomy). Proportions change from a height of four heads in a two-year old child, to six heads in a preadolescent, up to seven and a half heads, which is the correct proportion for an adult.

The female figure also corresponds to the height established by the classic rules, despite the natural morphological differences that set it apart from the male.

The classic rules of proportion states that the height of an adult figure is the equivalent of seven and a half heads.

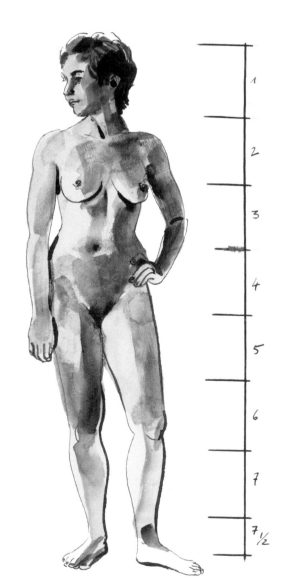

THE LENGTH OF THE ARMS

The height of the elbow, with the arm at the side, can be found at the same level as the hip, just below the waist. The total length of the arm, from the end of the clavicle to the end of the middle finger, is half of the length that separates the end of that clavicle from the bottom of the foot. Also, the height of the neck and the head is half the length of the arm.

The Relationship Among the Dimensions of the Body

The proportional harmony of a seven-head figure affects all of the dimensions of the body. Ideally, the length of the body should fit exactly inside a circle with its center at the pubic bone. The two resulting halves are inscribed into two circles with their respective centers in the sternum and at the knee. The total height is equal to the total width of the figure with its arms extended. The center of this width can be found between the two clavicles, and each one of these two new circles will have its center at the articulation of the elbow.

The ideal center of the human body is at the level of the pubic bone, and half of the total height equals the length of the arm.

The height of a child from two to four years of age is between four and five heads. This "disproportion" is due to the precocious development of the head in relation to the rest of the body.

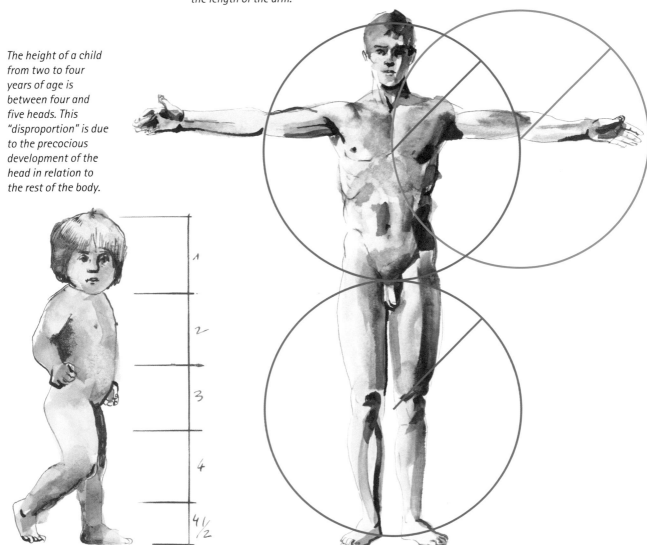

Basic Anatomy:
The Skeleton

The skeleton is an articulated structure of bones that supports the human body and that contains and protects the internal organs. Almost all of the 233 bones that form the skeleton are articulated and serve as levers where muscles contract. Most of them are arranged in pairs (to the left and to the right of the body's axis of symmetry), and even those that are the exception to the rule, such as the skull, the pelvis, or the vertebrae, are formed by two similar halves.

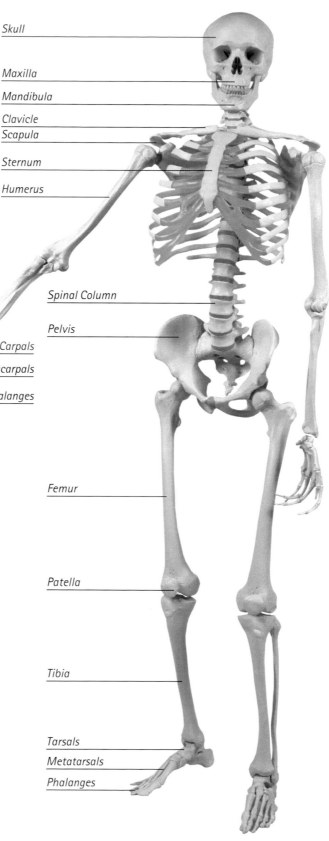

Skull

Maxilla

Mandibula

Clavicle
Scapula

Sternum

Humerus

Radius

Ulna

Carpals

Metacarpals

Phalanges

Spinal Column

Pelvis

Femur

Patella

Tibia

Tarsals

Metatarsals

Phalanges

Front view of the skeleton showing the most important bones.

Arrangement of
the Bones

The skeletal bones are located around the spine, to which they are directly or indirectly attached. The upper part of the spine supports the weight of the skull and the shoulder girdle (the group formed by the two clavicles and the two shoulder blades), where the bones of the upper extremities are inserted. The spine, in its central area, supports the ribs (rib cage), and the lower part rests on the pelvis and on the lower extremities.

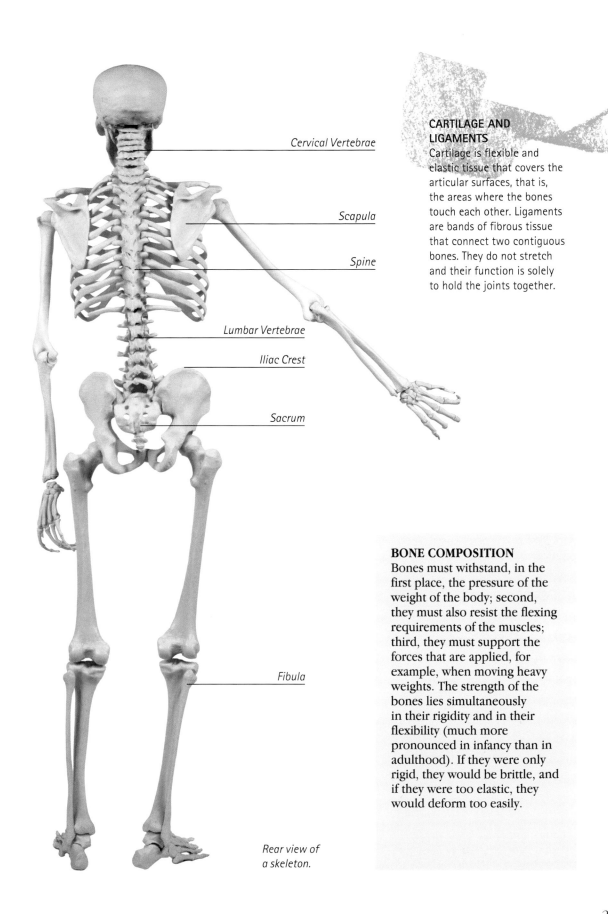

Cervical Vertebrae

Scapula

Spine

Lumbar Vertebrae

Iliac Crest

Sacrum

Fibula

*Rear view of
a skeleton.*

CARTILAGE AND LIGAMENTS
Cartilage is flexible and elastic tissue that covers the articular surfaces, that is, the areas where the bones touch each other. Ligaments are bands of fibrous tissue that connect two contiguous bones. They do not stretch and their function is solely to hold the joints together.

BONE COMPOSITION
Bones must withstand, in the first place, the pressure of the weight of the body; second, they must also resist the flexing requirements of the muscles; third, they must support the forces that are applied, for example, when moving heavy weights. The strength of the bones lies simultaneously in their rigidity and in their flexibility (much more pronounced in infancy than in adulthood). If they were only rigid, they would be brittle, and if they were too elastic, they would deform too easily.

Basic Anatomy: The Muscles

Muscles are fleshy masses of fiber, which cause the body to move when they contract in response to the nerve stimulus. The total number of muscles varies between 460 and 501, depending on different anatomists (there are muscles that can be considered as a unit or as a group). They overlap each other and are arranged in layers or planes. Visceral and motor muscles located in deep planes are not noticeable on the surface relief of the body.

The mechanics of the muscles obey the same laws that govern the arms of a lever—the muscle produces a force to balance a resistance (the weight that is to be moved) and the joint is the fulcrum of the system. Except for the cutaneous muscles, every muscular action is complemented by the action of another muscle group called the antagonist.

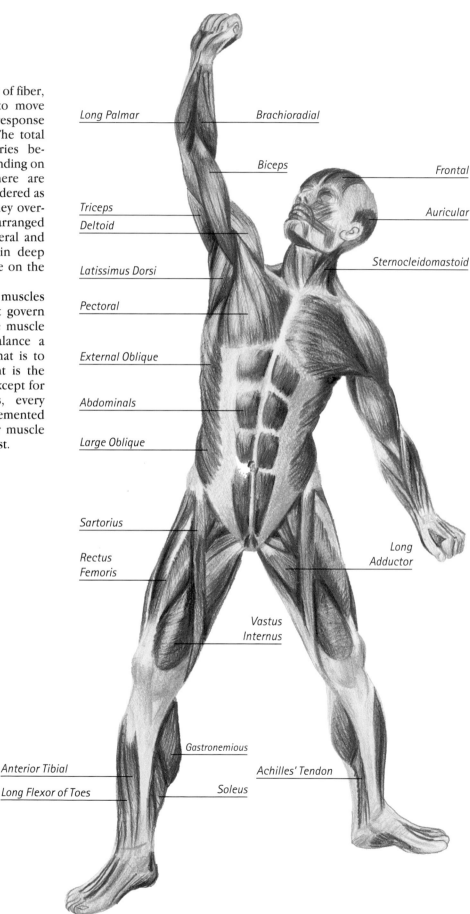

Long Palmar

Brachioradial

Biceps

Frontal

Triceps

Auricular

Deltoid

Latissimus Dorsi

Sternocleidomastoid

Pectoral

External Oblique

Abdominals

Large Oblique

Sartorius

Long Adductor

Rectus Femoris

Vastus Internus

Gastronemious

Anterior Tibial

Achilles' Tendon

Long Flexor of Toes

Soleus

View of the distribution of the muscles of the front of the body.

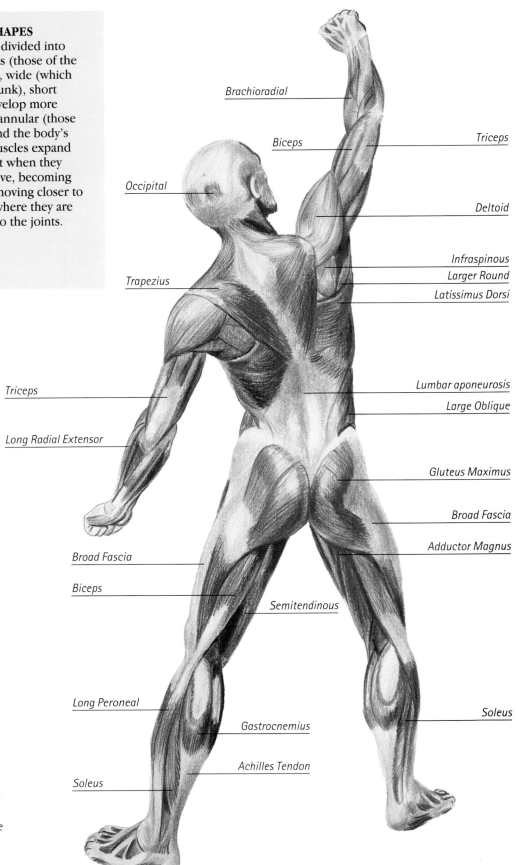

MUSCLE SHAPES

Muscles are divided into long muscles (those of the extremities), wide (which move the trunk), short (used to develop more force), and annular (those that surround the body's orifices). Muscles expand and contract when they become active, becoming larger and moving closer to the points where they are connected to the joints.

Brachioradial

Biceps

Triceps

Occipital

Deltoid

Infraspinous

Larger Round

Trapezius

Latissimus Dorsi

Triceps

Lumbar aponeurosis

Large Oblique

Long Radial Extensor

Gluteus Maximus

Broad Fascia

Adductor Magnus

Broad Fascia

Biceps

Semitendinous

Long Peroneal

Soleus

Gastrocnemius

Achilles Tendon

Soleus

Arrangement of the muscles of the back and the back of the legs.

Drawing the Trunk

To draw the trunk easily, one must imagine it as a rectangular shape with another rectangle (the head) on its top part. Dividing the entire composition in four parts, the top one representing the head must be one fourth of the total length. The remaining three parts (the largest rectangle) represent the trunk, and it can contain the essential anatomical references as shown in the illustrations on this page. The trunk's basic proportions are the same for the front, as for the back and the side. The respective anatomical references should be indicated in each case. These marks or references are illustrated on the grids to the right.

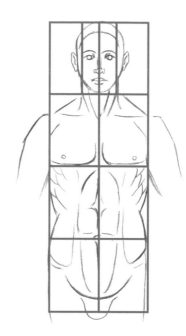

The grid for the trunk, seen from the front, is four modules high (that is, the vertical dimension of the head). The references indicated on this grid are very helpful for drawing it.

The male trunk is much more muscular and wider than that of the female.

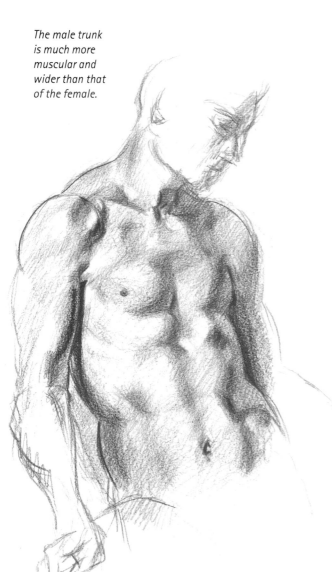

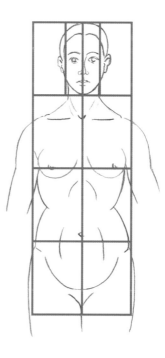

The proportions of the female trunk, seen from the front, are identical to those of the male trunk. The references vary only in size and placement.

FRONT VIEW OF THE TRUNK
The bottom quarter of the grid, seen from the front, is equal to the distance between the pubis and the navel. The quarter immediately above represents the distance between the navel and the lower edge of the pectorals. The following module includes the neck and the shoulder line. The top module is filled by the head.

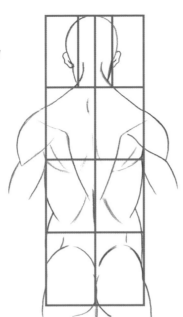

Main anatomical features of the male trunk, seen from the back.

REAR VIEW OF THE TRUNK
The grid for the back must include the top edge of the buttocks, the outline of the shoulder blades, and the line of the spine. For the profile view, it is sufficient to transfer all these references, adapting them to the correct contours for that point of view. In all cases, the basic grid serves as the starting point for the drawing.

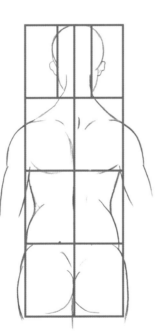

Grid of the back of the female trunk with its basic anatomical features.

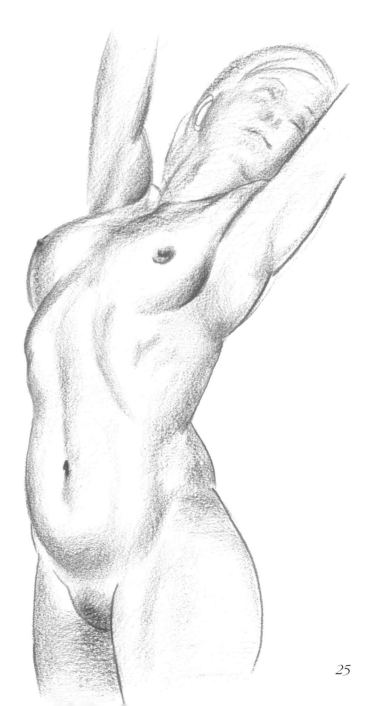

The lines of the female trunk are always more rounded and continuous than those of the male trunk.

Drawing the Legs and the Arms

A leg can be drawn as a trapezoid, whose inside edge is a vertical line, while the outside is an angle that goes up from inside to outside. The calf can be blocked in easily using concentric curves.

The arm and forearm, seen from the front, do not progress in a straight line but bend slightly at the elbow and wrist. The grids would be as follows: a rectangle for the arm, and two trapezoids of different sizes for the forearm and hand, as can be seen in these illustrations. It must be remembered that the upper arm is somewhat longer than the forearm, and that the latter is somewhat longer than twice the length of the hand.

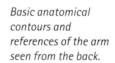

A six-module grid (each one half the length of the forearm) can be used to easily block in the main references for the arm, which in this case is seen from the front.

In this rear view of the trunk, the contours of the arms can be compared with the grids next to them. Beginning with a well-proportioned grid, it is easy to draw the shape of the arm.

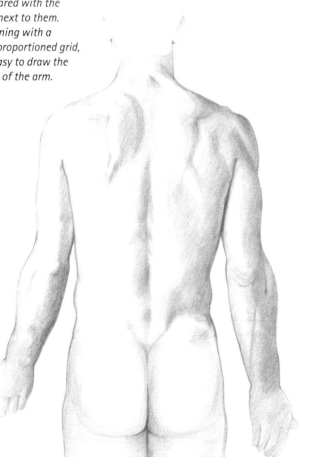

Basic anatomical contours and references of the arm seen from the back.

Basic anatomical references for the arm seen from the side.

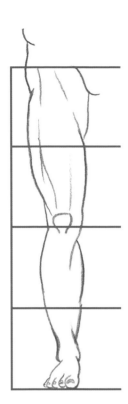

The basic module for the leg's grid is half the length of the thigh. The illustration shows the grid for the leg seen from the front.

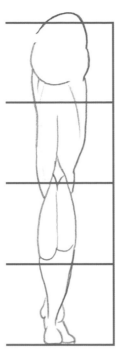

Basic grid for the leg seen from the back.

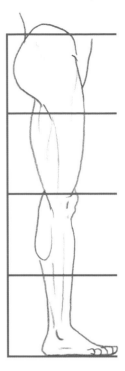

Basic grid for the leg seen from the side.

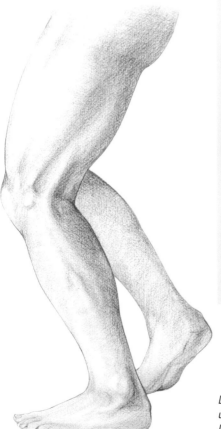

ALIGNING THE ARMS AND THE LEGS

When drawing the arms as well as the legs one must first keep in mind that the axis of the leg does not follow the same direction as the axis of the calf. The thigh tilts slightly toward the central axis of the body, while the calf descends vertically. And, second, the arm and the forearm, seen from the side, are not perfectly aligned either. They form a slight obtuse angle at the height of the elbow.

Drawings like these can be created using the grids seen previously and a life model or a photograph.

Drawing the Hands

The hand, because of its range of movement and position, can be considered an artistic subject in itself. It is the part of the body that can offer the largest number of poses because it consists of five fingers with three joints each. Classical painters had a true "repertoire of hands" in various positions to express the different moods of the figures. In portraits, the hands can transmit clear psychological suggestions to the viewer through gestures.

Proportions

Ideally, the total length of the hand (from the base of the thumb to the tip of the middle finger) is twice its width. Blocking in the hand in a rectangle of these proportions, the middle line of this rectangle (that divides it in two equal squares) would coincide with the knuckles and the last bone of the thumb, on the back, and with the base of the fingers on the palm. From this, one can deduce that the length of the middle finger is half the hand's total length. The ring and index fingers are the same size, somewhat shorter than the middle one, and the little finger extends approximately to the last joint of the ring finger.

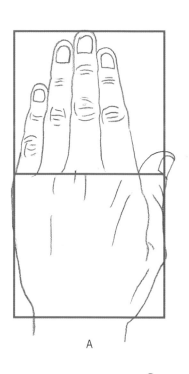

A

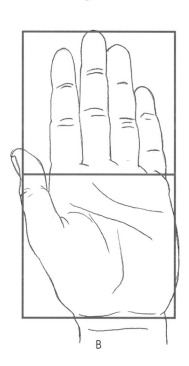

B

Proportions of the top of the hand. The middle line is located at the height of the knuckles (A).

Proportions of the palm of the hand. The middle line of the rectangle is located at the base of the fingers (B).

The knuckles are arranged in nearly concentric circles with respect to the palm.

A FLEXIBLE PLANE
To make it easier to draw the hand, it can be helpful to imagine it as a flexible plane from which the fingers extend. These two-dimensional shapes (like paper cutouts) can be drawn easily and efficiently.

The Thumb

A practical sketch of the hand consists of a simplified drawing of the finger joints, resembling cylindrical figures joined together.

The thumb is worthy of additional comments apart from the other fingers; its shape and movement clearly set it apart. It is also different for its particular influence in the general proportions of the hand. When the fingers are together, the tip of the thumb is a natural extension of the almost perfect curve formed by the joints of the other fingers. When the thumb moves away from the palm, its tip makes another ideal arch, which is not exactly the extension of the previous one. The thumb is located in a different plane from the rest, in such a way that when the hand is seen in profile, it presents more of a frontal view than the other fingers, and with the hand seen from the top, it appears to be more in profile.

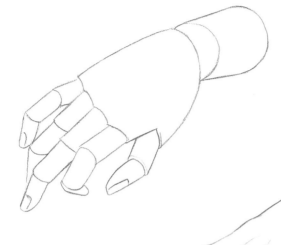

A drawing made from the previous sketch.

This shows another position of the hand drawn by blocking in a sketch made with cylindrical forms.

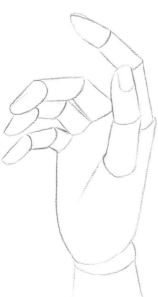

Developed from the previous sketch. Naturally, to produce these results, the artist must work from a real model, either from life or from a photograph.

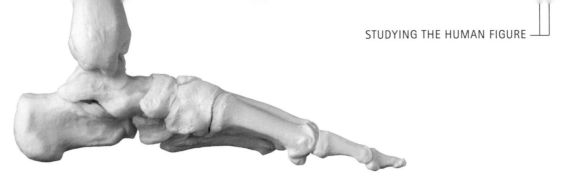

The bones of the feet (heavier at the heel and progressively thinner at the toes) form a curvature on the bottom that favors the elasticity required for walking and running.

The Feet

Although they are so irregular in shape, feet are much easier to draw than hands, because they have much less movement. If you know how to correctly draw the four basic views (inside profile, outside profile, front, and back), you will be able to tackle almost any pose with guaranteed success.

Front and Side Views

Seen from the side (either inside or outside), the foot can be blocked in with a right triangle in which the heel would fall within the ninety-degree angle. This triangle can be divided into three equal parts, each one the width of the ankle. The front part will determine the area occupied by the toes, the middle part corresponds to the bottom of the foot, and the rear will define the heel. These proportional divisions can be applied more clearly on the outside of the foot. The foot, seen from the front, looks like a triangle whose base forms a curve along which the toes are aligned. Seen from the back, the proportional grid of the foot is defined by two overlapping triangles. Any one of these basic grids would provide a good point of departure from which to draw the feet.

Grid for a foot seen from the front. The foot can be blocked in with a triangle that has a curved base. This curve or arch corresponds to the arrangement of the fingers (A).

From the back, the grid for the foot is reduced to two triangles connected near their points, the bottom one being smaller (B).

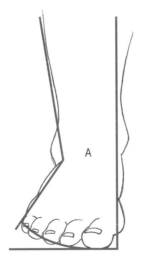

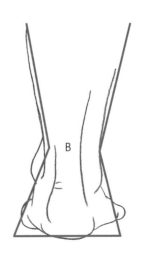

The foot seen from the side can be blocked in with a right triangle whose base is three times the width of the ankle. The middle third corresponds to the arch.

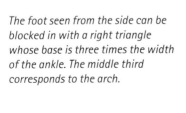

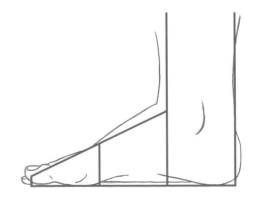

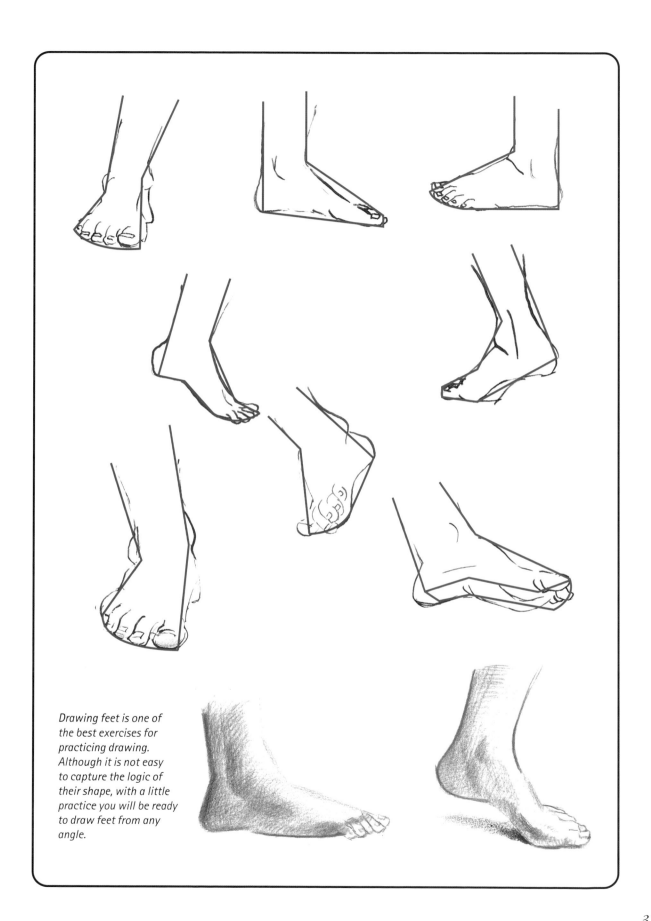

Drawing feet is one of the best exercises for practicing drawing. Although it is not easy to capture the logic of their shape, with a little practice you will be ready to draw feet from any angle.

The Head

The structure of the head can be studied just like any other shape of the body's anatomy. Despite the many variations that the head and the face can present, there are some basic proportions that provide a human appearance both to men and women. But this is not the only aspect that has to be considered when drawing a head. The personality and psychology of the figure are inherently linked to the face, and the artist must devote special attention to its representation.

The Proportions of the Head

The head seen from the front is symmetrical and this line of symmetry already represents a first reference for the artist. Considering just the outline of the skull, without including the hair, the center stems from the bridge of the nose, just between the eyes. The basic module of the human head is approximately equal to three and a half times the height of the forehead (from the roots of the hair to the base of the eyebrows). Therefore, the forehead represents the basic measurement that determines the proportion of the other parts of the face.

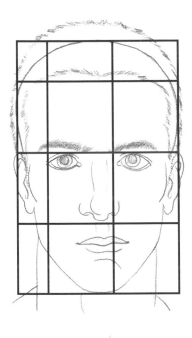

The proportions of the head are three and a half modules in height (from the chin to the top of the skull) by two and a half modules wide (from ear to ear).

The bottom lip is located by dividing the bottom module in two. The distance between the eyes is equivalent to the width of the eye.

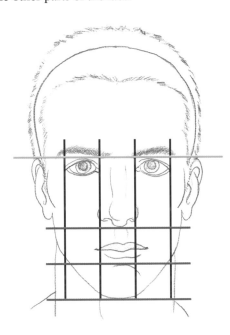

The profile of the head can be drawn in a square with a side equivalent to three and a half modules, keeping in mind that the modules are equal in size to those used to block in the head seen from the front.

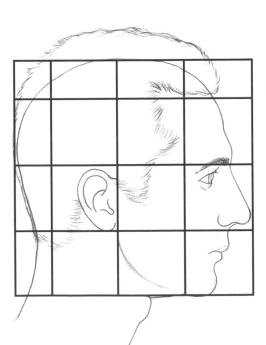

WITHOUT EXACT MEASUREMENTS
The proportions given for drawing the face are to be used only as guidelines and it would be wrong to apply them with too much precision. It is much better (more realistic) to draw partitions that are approximately equal; this way the features will appear more lively.

Divisions and References

The following references are obtained by drawing a series of horizontal lines that divide the head into three and a half units: the top of the skull, the hairline, the eyebrows, the placement and disposition of the ears, the base of the nose, and the lower profile of the chin.

By applying the same grid of the forehead to the width of the head, you will notice that it can be divided into two and a half units. These divisions provide new references, which, added to the previous ones, help in the placement of the features seen from the front.

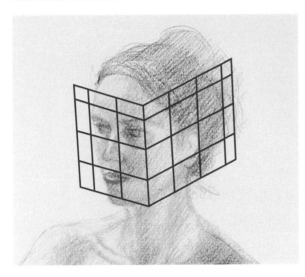

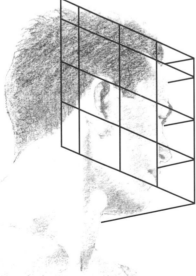

By imagining the basic grid in perspective, drawing the head of a man or a woman can be approached with complete confidence.

THE EYES

The human eye is a sphere covered by the eyelids. For the artist, the eye is first of all a sphere with an oval opening (the eyelids). Knowing how to draw this sphere in any position makes it easier to approach drawing the eyes from any point of view.

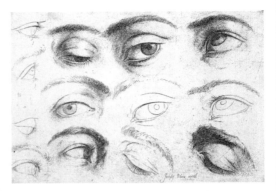

José Ribera, Study of Eyes. Biblioteca Nacional (Madrid, Spain).

THE LIPS

With the mouth closed, the lips occupy a curved plane similar to that of the eyes, although more irregular. The lower lip is fleshier that the top one, and the latter has a slight indentation in the middle. With normal lighting, the upper lip always appears more shaded than the bottom one. Never outline the contours of the lips; it is best to suggest them with a combination of light and shadow.

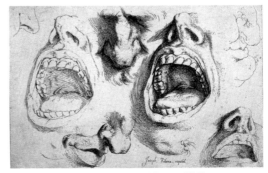

José Ribera, Study of Mouths and Noses, Biblioteca Nacional (Madrid, Spain).

Developing the Figure

The diagrams that we have seen so far are a great aid for acquiring a general view of human anatomy and for knowing how to draw it quickly and efficiently. They are all useful for representing the human figure, whether for sketching or for doing a detailed and realistic drawing. First, it is important to plan the diagram for the pose using the basic axes—that of the trunk and those of the arms and legs. When this linear frame has been completed, the basic characteristic forms of each anatomical area are drawn over it, centered around each axis and adjusted for possible foreshortening. The indications of lines will be applied over those flat shapes, from which the drawing will progress until it is completed.

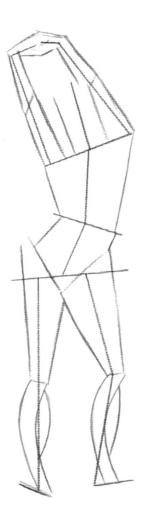

The diagram of the body using the simple forms previously studied, properly articulated to convey the correct movement.

Using the previous diagram, the contours are created by drawing them lightly with a pencil, giving them the appropriate anatomical shape.

Finally, the arms and legs are drawn with a simple combination of light and shadow until the actual volume of the figure has been achieved.

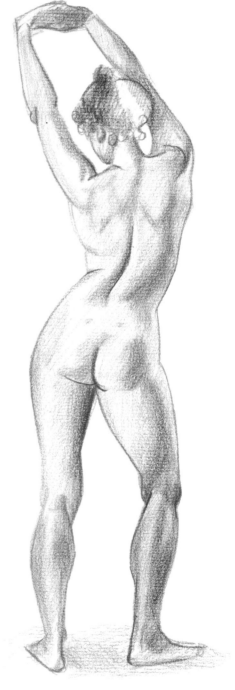

Creating the Volume

Every drawing is based on two-dimensional shapes and the result is a figure defined by contours and profiles. To create a more accurate representation of the actual volume of a human figure, it is possible to introduce some line work that suggests three-dimensionality. Without abandoning the synthesis, such diagrams should be based on curved lines rather than on straight ones, because curves are better for representing the roundness of the volumes. Working within the initial proportions and dimensions, the depth of each anatomical area can be drawn using one or several simple curves such as ovals, parabola, and so on. Once this simple method is understood and practiced, it is possible to interpret any pose that departs from a very complete repertoire of lines and forms, and to choose the most appropriate ones for each function.

FORESHORTENING

Any pose presents itself with several parts of the anatomy in foreshortening, that is, in perspective. This foreshortening requires alterations of the basic forms proposed in previous pages—rectangles end up being trapezoids or rhomboids, open curves can be much more closed, and, in general, dimensions are reduced. Therefore, for each pose it will be necessary to find the diagram that best represents its anatomy. But always keep in mind that such diagrams must be composed of simple lines and forms.

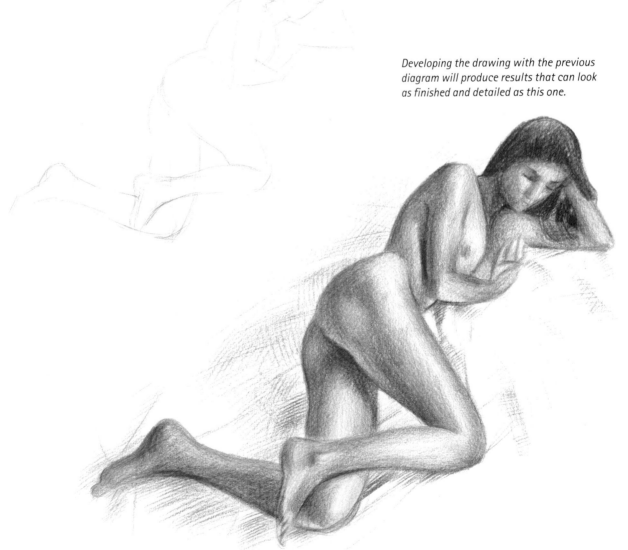

To draw the figure, the proportions must first be defined using simple shapes.

Developing the drawing with the previous diagram will produce results that can look as finished and detailed as this one.

The Movement of the Body: Walking

The human body in motion has an internal logic. Each and every one of the body's walking movements of the arms and legs responds to two essential factors: traction and balance. Traction is mainly carried out by the legs, while the balance is achieved by the arms, which compensate for the constant redistribution of the weight during walking. Thus, the forward motion of the right leg is compensated by the backward motion of the right arm, and vice versa. The relationship between movements creates a continuous and stable cadence, and the walking motion is so rhythmic that most of the time one is unaware of it.

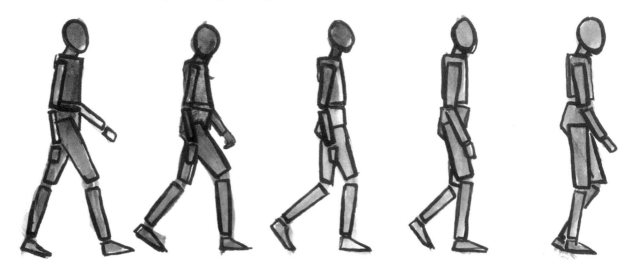

Basic sketches of walking movements. These diagrams make it easier to draw figures in motion.

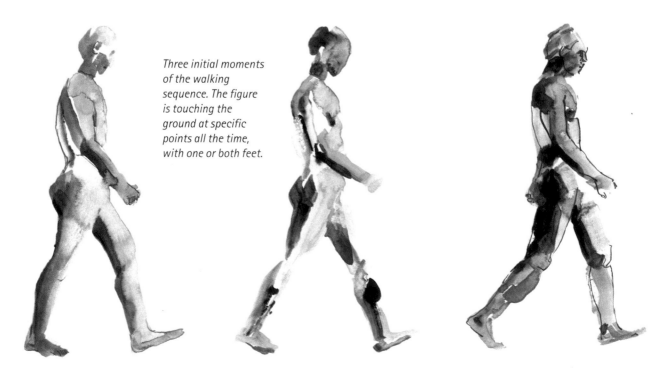

Three initial moments of the walking sequence. The figure is touching the ground at specific points all the time, with one or both feet.

Drawing the Figure in Motion

These diagrams show the basic sequence of walking movements in relation to the stationary position. The position of the head and trunk remain practically unchanged through all the stages, and the legs appear completely extended only when the weight of the figure falls clearly on one of them. The arms maintain a relaxed position, slightly flexed; only the shoulder makes back and forth movements.

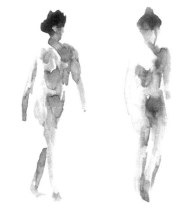

These sketches show the movement in a very simple way, demonstrating the basic motions of walking.

BALANCE
The best way to indicate the balance of a figure in motion is to imagine a vertical line that runs through the drawing along its central axis, from the head to the floor. This line must always coincide at some point with the contact surface of the bottom of the right or left foot. However, this would be true only for figures that move forward slowly, not for those that take big steps, and even less so for representing running motions.

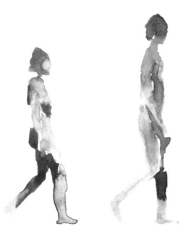

The sketches of walking figures can be done very quickly, keeping in mind the basic gestures of the walking motion.

Continuation of the walking sequence. The trunk rolls slightly, reaching the highest position when the leg that carries most of the weight extends the body's vertical line.

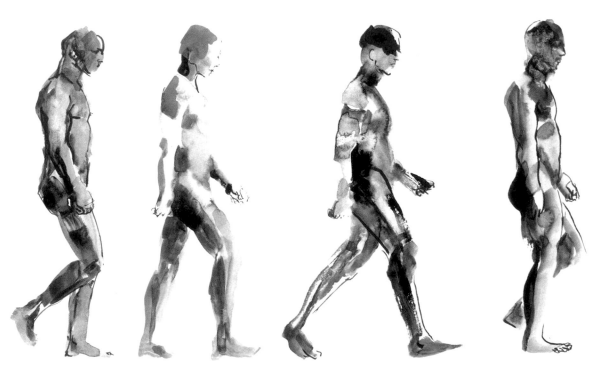

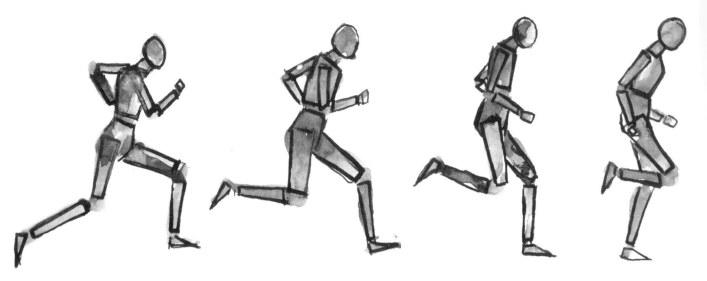

Running

Running involves a series of movements that are completely different from walking. The only thing that both ranges of movements have in common is the rhythm of the relationship between the back-and-forth movements of the arms and legs. The trunk is visibly tilted during running, keeping the center of gravity of the figure tilted forward. It could be said that a figure that is running is always falling forward and trying to avoid that fall at all times with the quick advance of the legs. This means that the center of balance of a running figure cannot be defined with the method indicated for walking, because the vertical axis during the running sequence often falls outside of the point of contact of the feet with the ground.

Sequence of running movements. It is especially important to notice the relative positions of the arms and legs at each stage of the sequence.

DRAWING A FRONT VIEW OF A FIGURE RUNNING
Seen from the front, all the extremities of a running figure are foreshortened (that is, in perspective). This makes drawing the figure more difficult than if it were in profile. For this type of drawing, it is best to become familiar with the characteristic movements using photographs, choosing images that can be organized in a logical sequence.

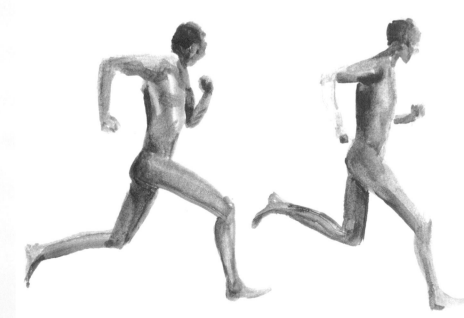

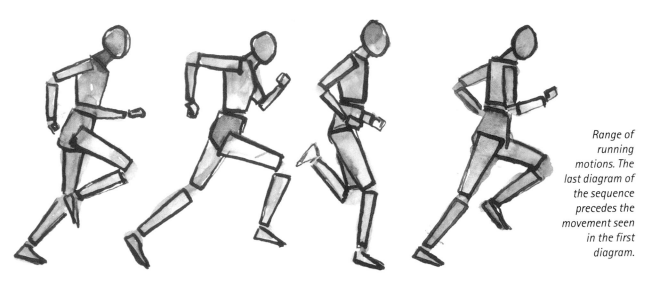

Range of running motions. The last diagram of the sequence precedes the movement seen in the first diagram.

Motion Sequence

The drawings above, which show the sequence of running motions, make it easier to observe the forward-tilted position of the trunk. This tilt is most pronounced a moment before the foot that is farther out touches the ground, and it is straighter just before the foot that is behind leaves the ground. The arms are more flexed than during walking, and the back-and-forth motion of the shoulders is more visible. The legs also flex much more than they do when walking, to the point that the calf can lift the foot almost to the level of the buttocks. The leg remains flexed while touching the ground, and appears completely extended only before or after the contact.

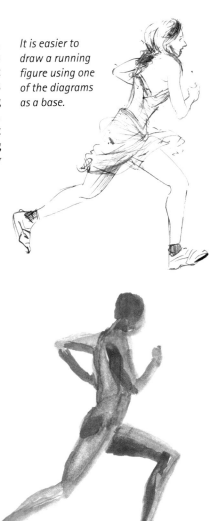

It is easier to draw a running figure using one of the diagrams as a base.

Figures in Motion

A representation of motion looks more credible when it is drawn as a quick sketch using simple media. This means that being able to synthesize is the most valuable quality for an artist who wants to approach this type of drawing. A single line can define the position of the arm, a mass of color strategically applied can suggest the trunk, and a simple brushstroke can define an entire figure. The immediacy of the movement may give the impression of a hurried drawing, but it will very faithfully represent a moving body. These pages show various examples of figures in motion captured by the artist almost "in flight." Most of them lack details, but they all include what is required for a sketch to show vitality and energy.

FAST MEDIA
The fastest media and therefore the most useful for sketching bodies in motion are the simplest ones: a pencil, a fountain pen, any black or colored lead, or any implement that releases ink. The wash is another one; a brush loaded with a single color can create the sense of movement with just one application.

Sketches of bodies in motion can be created from a life model or from a photograph. The most logical approach is to use a photograph to represent the movements that are too quick to be captured from life. This makes it possible to memorize the logic of the body's movements to such a degree that the artist can draw them without any references.

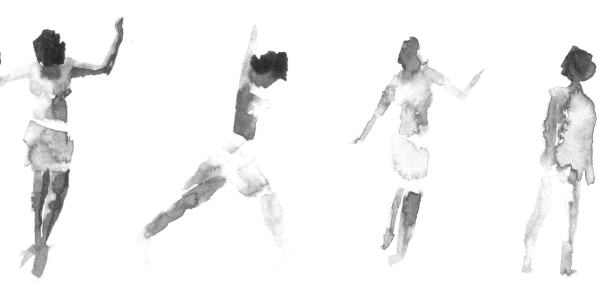

Drawings of children present a peculiar movement, which is characterized by the large size of the body in relation to the arms and legs.

Running can be represented by using the sketches seen in previous pages, and without the need for a model or photograph.

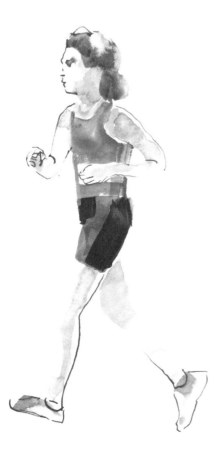

THE VALUE OF COLOR

Most of these drawings have been created with simple strokes of watercolor. Tonal variations that suggest light and shadow have been produced almost by accident. A first application of color suggests the volume, and the next application is done according to the previous one. There is not much time to calculate the effects, and what appears to be a mistake often contributes to an increased feeling of movement in the sketch.

This figure has been created with a single wash. The quickness of the execution is very appropriate for the immediacy of the movement. Too much precision in the drawing and the color tend to be counterproductive in the representation of movement.

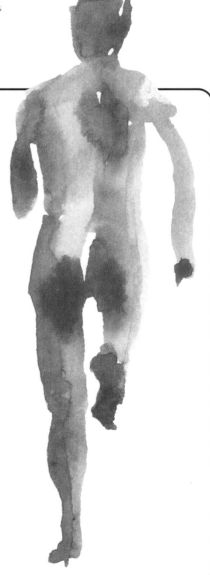

Foreshortening

Foreshortening is the view of a body or part of a body in perspective. Drawing foreshortening requires some practice and also knowing the basic anatomical shapes, because foreshortening is an interpretation of those shapes in perspective. Any given figure always presents some part of itself in foreshortening, whether it is the face, an arm, a hand, and so on. But this consists of foreshortening without much significance, and it hardly alters the "normal" view of the anatomy. However, when a figure is seen from above, from across the floor, or when an arm or leg is drawn from an unusual point of view, the usual shapes of the anatomy must be interpreted in a different way to understand the logic of this perspective.

THE MASTERS OF FORESHORTENING

During the Renaissance and Baroque periods, many artists showed their extensive knowledge of the anatomy by filling their compositions with figures in foreshortening, displaying the most unusual, even forced, positions. Any theme justified contorted bodies that gave a new dimension to human anatomy. Two of the great masters who created dramatic effects with foreshortening were Tintoretto and Rubens.

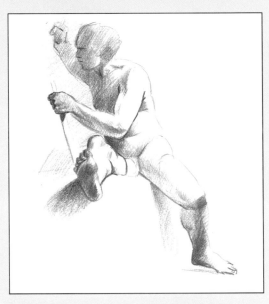

This figure shows the right leg in foreshortening. The play of light and shadow contributes to the normal appearance of that part of the body.

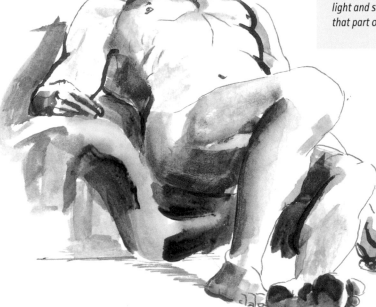

Figure in foreshortening with the diagram (above) corresponding to its anatomical arrangement. Foreshortening produces shorter dimensions than those of the real body.

How to Draw and Paint the Human Figure

Every artist's style is the direct result of his or her personal way of using drawing and painting materials. At the same time, the materials themselves have certain requirements in the way they are used that the artist must respect.

The techniques and procedures used to represent the human figure are of vital importance in order to achieve good results. A painting or a drawing will vary not only as a result of the techniques employed (color, finish, and so on), but the feeling and emotion conveyed to the viewer will also change, depending on the medium and the way it is used. Certain media are warmer than others, or more spontaneous, more flexible, or intimate. Each one of them has its own expressiveness, which is inevitably transferred to the canvas. This is why it is so important for the artist to know the procedures so well. Each theme will require a medium that best fits the intentions of the artist and of what he or she wants to express. It is not the same to paint a figure in full motion, then a portrait, or a still life, or an outdoor scene with a group of people; each one of these themes requires a specific treatment. The following pages will present various options to fulfill those requirements.

◆

The expressiveness of a drawing or a painting of the same figure will vary depending on the medium used.

◆

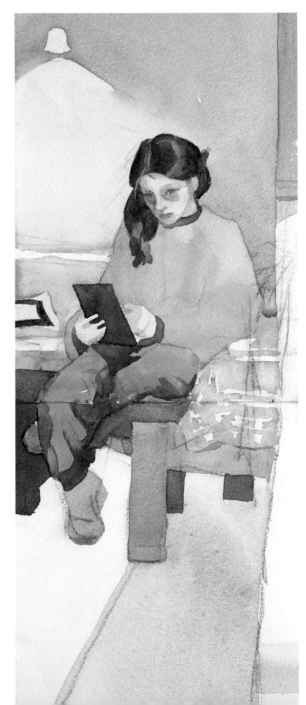

Watercolor is one of the most delicate media, and when used for painting figures can produce results of incredible intimacy. Watercolor by Mercedes Gaspar.

The Pencil

A pencil is the easiest and most direct of all drawing media. It consists of a graphite stick inside a wood casing. There are people who still like to call them "leads" because when graphite was discovered in the sixteenth century, it was mistakenly believed that the points were made of that substance. Artists may draw with soft lead, which make very dark and heavy impressions. Hard lead is used for very delicate drawings. There is a wide range of hardnesses that are classified with symbols, from H for hard to B for soft. There are also thick leads without wood casings, suitable for sketching and large formats.

A Combination of Intensities

Using several pencils with different lead allows the artist to control the intensity of the line and to complement the consistent gray tone of graphite lead. Hard-lead pencils make very thin and soft lines, which are ideal for small details and for the most subtle shading. Soft lead is good for highlighting the most important or shaded areas of the figure, combining line and shading that strongly stands out against the white of the paper. Also, it is possible to create a different range of intensities with one pencil alone, applying more or less pressure as needed.

> **CHARCOAL**
> Charcoal, like pencil, is a monochromatic and flexible medium. It is used for sketching as well as for regular drawing. Charcoal is good for making lines, but the best results are obtained when it is used to shade large areas. The tonal richness of the charcoal suggests a romantic appearance, making this a very suitable medium for portraits.

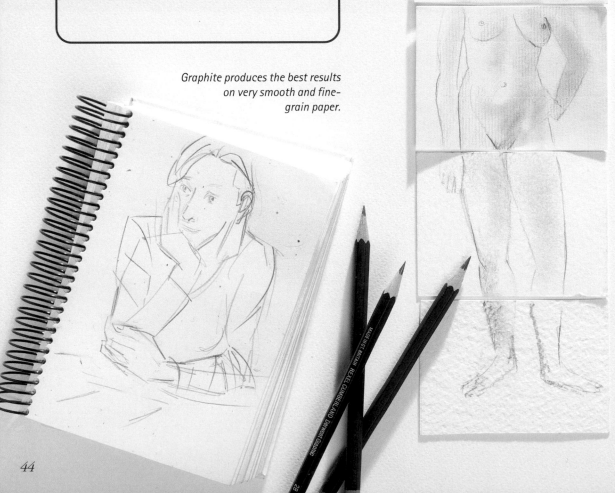

Graphite produces the best results on very smooth and fine-grain paper.

Pencil shading can be applied very freely or in
a more controlled manner, planning the
distribution of light and shadow systematically
and combining planes of various intensities.
Drawing by Miquel Sans.

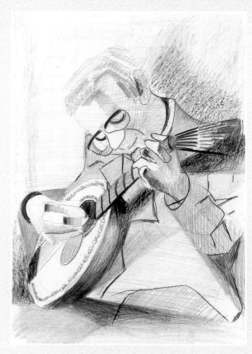

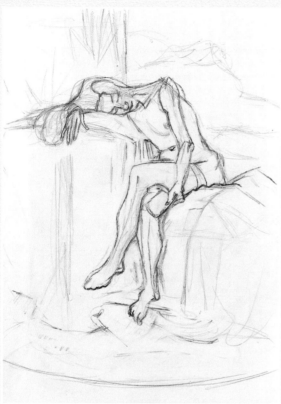

Pencil lines are sufficient to show the
shape of a figure. The three-
dimensionality and modeling effects
have been created with the variations
of line thickness and intensity.

The use of soft graphite leads that
produce heavy lines on heavy-
grain paper is recommended.
Many professionals use thick
graphite sticks by themselves or
inserted into lead holders of
various sizes.

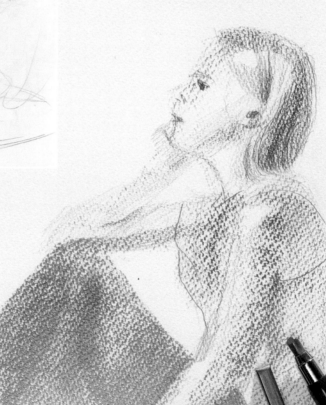

Sketching with Pencils

Quick sketches are the basis for studies of the human figure. Every work of art begins with one or several sketches. A quick sketch can mark the beginning of a project or simply be its preliminary preparation, but in all cases, the sketch is a vital tool because it becomes the foundation for the work. Because of their simplicity and portability, pencils are the most common medium for sketching outdoors. A sketchpad can be carried anywhere, anytime, and it is always ready for use. The paper should not be too thin or too smooth. A surface that has some roughness highlights the lines and produces very warm results.

This sketch has been drawn with very thick graphite lead. The lines are used for describing the contours as well as for modeling the forms.

Graph paper is a very ingenious way to create good sketches that can later be incorporated into a painting. Graphing the canvas on a larger scale makes transferring the drawing very easy.

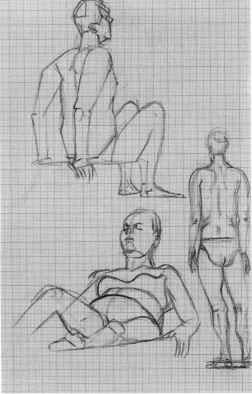

A simple sketch done in pencil can produce very sophisticated results.

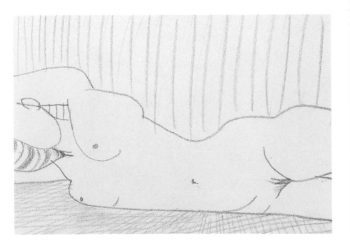

Light and Shadow

Shading sketches should be done very lightly. It is important to find a balance between light and shadow to build the figure with the basic elements. Excessive shading is a problem that reveals the inexperience of an artist and also makes the drawing very confusing. In larger formats, the artist should begin synthesizing light and shadow progressively until it reaches its full complexity. Shading should never be approached in detail until the figure is completed.

SHADING
Pencil shading can be crosshatched or spread with the finger. The thicker the pencil point, the heavier the shading will be.

Pencil sketches should be drawn loosely. This drawing has many tentative lines that were applied while the artist was searching for the correct volume.

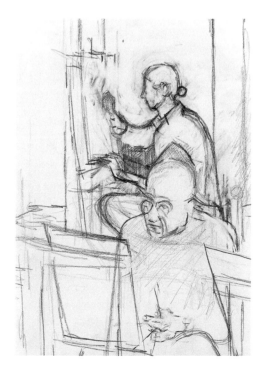

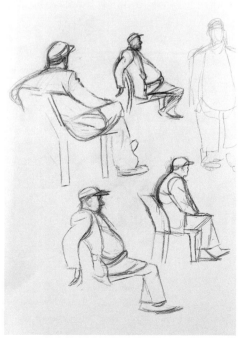

Sketches done outdoors of the same figure in different poses. Any situation can prompt a very interesting pencil sketch.

A Portrait in Pencil

A graphite pencil is not only a good tool for sketching, making preliminary studies, paintings, or for other major works of art, but it can also be used as the sole medium, producing very properly finished results. To observe the process, we will follow the drawing of a pencil portrait in these pages. The process is simple and does not involve any complicated techniques; different intensity line and shading is all that is involved. Three pencils are used in this project: hard (H) for the initial lines, medium (2) for the soft shadows, and soft (6) for the darkest shadows.

MATERIALS
- Graphite pencils: H, 2, and 6
- Fine-grain drawing paper

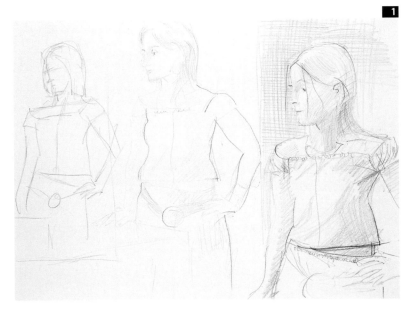

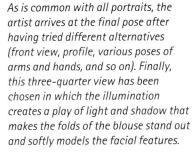

As is common with all portraits, the artist arrives at the final pose after having tried different alternatives (front view, profile, various poses of arms and hands, and so on). Finally, this three-quarter view has been chosen in which the illumination creates a play of light and shadow that makes the folds of the blouse stand out and softly models the facial features.

1 Several preliminary sketches were created to try out different poses and arrangements. The greater the knowledge of the figure and its movements, the easier it will be to correctly lay out the portrait.

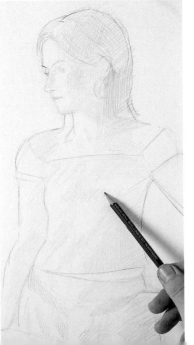

2 The initial drawing contains all the information that pertains to the figure, with the exception of the modeling. This will be laid out with very tentative lines, which will define the shaded areas, paying special attention to the folds and creases of the blouse.

TECHNIQUES USED

- ◆ Proportions of the trunk and arms ◆
- ◆ Blocking in the figure ◆
- ◆ Pencil drawing ◆

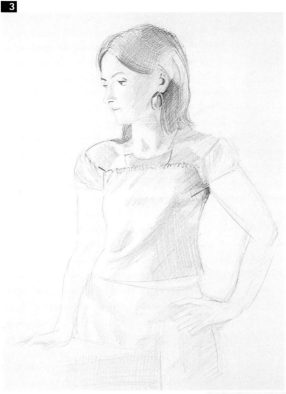

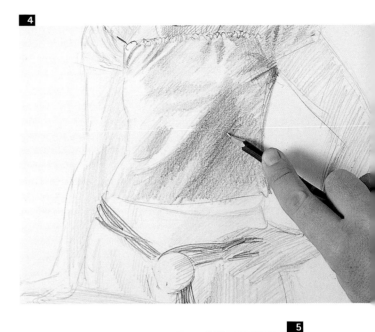

3 Once the main areas of light and shadow have been determined, contrast must be applied to convey the feeling of volume. The most intense shadow corresponds to the hair. A soft lead is used to darken that area with crosshatching.

4 When the artist is confident that the shaded areas have been properly identified, their intensity is evaluated and adjusted as needed. It is important to make a soft transition between light and shadow on the most prominent folds and to apply more contrast to the smaller ones.

5 There was no need for drawing the background because the light effects were already clearly defined. The crosshatching procedure has been controlled at all times to create a coherent effect around the folds of the blouse. This effect provides the harmony of the final drawing.

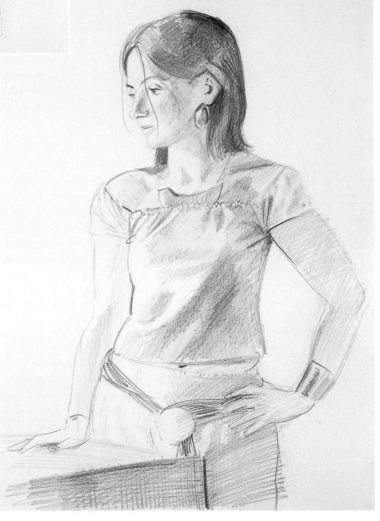

Ink

Ink is a medium that can be applied with different implements, from a dip pen to a brush, and used for different styles, from the most meticulous, realistic drawing to the most liberal and flexible representation. Black India ink and dip pens are the most traditional materials. A drawing executed with a dip pen has a special charm, because it is extremely sensitive to the lightest movement of the hand, whether it is its vibration or the pressure that it applies to the paper. These drawings should be done with lines and contours, almost like oriental calligraphy. But it is also important to practice crosshatching, drawing with a reed pen, and using the brush, which all produce more casual and artistic results.

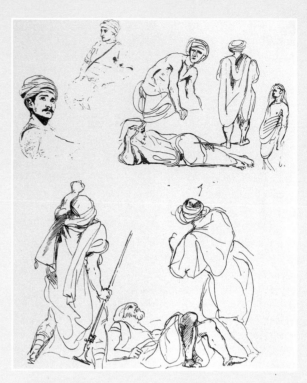

Eugène Delacroix, drawings from his sketchbooks. Musée du Louvre (Paris, France). These sketches are true masterpieces of graphic synthesis, in which the artist has been able to introduce a great number of realistic elements with a minimum number of lines.

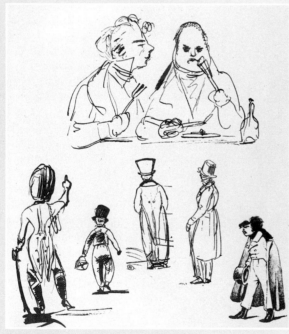

Eugène Delacroix, drawings from his sketchbooks. Musée du Louvre (Paris, France). The sketches created with a dip pen require confidence and precision. Mistakes are permanent and corrections require new lines.

DIP PENS AND FOUNTAIN PENS
Dip pens with metal nibs are available in different thicknesses
and degrees of flexibility, and sold separately to be inserted
into a wooden handle. Nowadays, there are several models
where the nib is permanently attached to the handle, which
also includes an inkwell or reservoir. There are also illustrator
pens of various thicknesses with an automatic ink flow in
black, sanguine, and sepia colors. Pens and fountain pens
increase the range of possibilities.

Graphic Design

India ink is very black, dense, and shiny. When ink is
applied to white paper, the result is more graphic than
artistic, suggesting art forms that are based on lines and
masses of color rather than on shadows and atmospheric
effects. The immediacy of this medium makes it very
suitable for quick sketches and studies of urban scenes,
which may include several figures in various poses next
to tools and machines for everyday use.

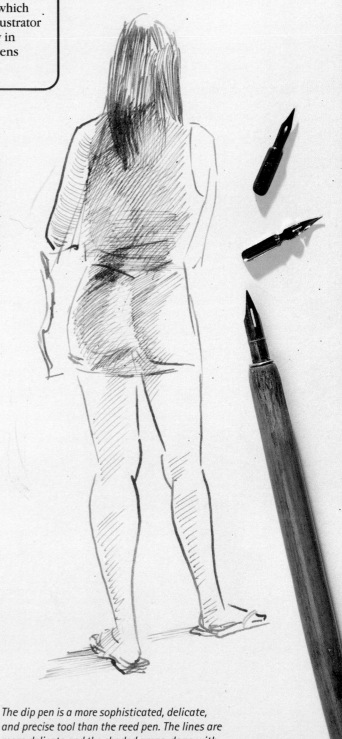

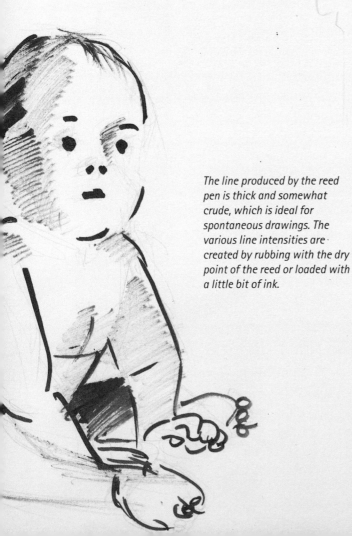

*The line produced by the reed
pen is thick and somewhat
crude, which is ideal for
spontaneous drawings. The
various line intensities are
created by rubbing with the dry
point of the reed or loaded with
a little bit of ink.*

*The dip pen is a more sophisticated, delicate,
and precise tool than the reed pen. The lines are
more delicate and the shaded areas, done with
crosshatching, can be created in a range of
intensities.*

51

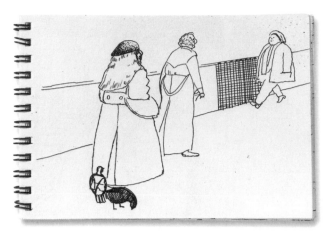

A small sketchbook is easy to carry and can be used at any time for drawing with a dip pen or a marker.

A brush can be substituted for the dip pen with the advantage that the lines are much more energetic and simple, and its intensity can be controlled by diluting the ink with distilled water. Drawing by Vicenç Ballestar.

Sketching with Ink

The brush is one of the most common tools for drawing with wet media. Of those, the sketches or studies done with washes from live models are the most frequent. The immediacy of the brush has no comparison. The brush is a drawing tool that allows the artist to express movement, light, and atmosphere with a minimum of materials, and that produces results of a sketchlike quality that are still good enough to be considered works of art. Besides, it is one of the best exercises for the artist. Brushes are good for training the hand, the perception, the retentive memory, and the ability to see and understand the shapes almost instantaneously and to transfer them to paper.

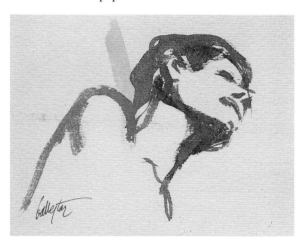

Special illustrator pens are available in black, sanguine, and sepia colors, and in three different thicknesses, plus a brushlike tip that can draw lines of various widths.

Spontaneous sketches can be finished or modified according to the imagination of the artist, which can be based more on his or her inventive personality than on the observation of reality.

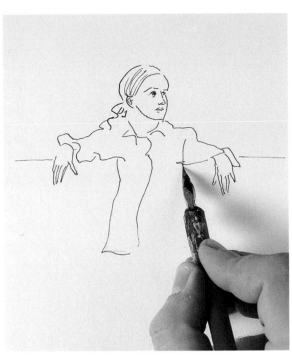

Mixing with Ink

Drawing with ink allows many combinations with other procedures. These combinations could be considered mixed techniques, although they do not require complicated methods or specific preparation to achieve certain results. Watercolors and ink are similar media and many artists combine them in many different ways. In this case, the watercolor is nothing more than a background against which the ink drawing is created. The purpose of the drawing is to highlight the form and the details. Thanks to the watercolor background, the ink drawing can be reduced exclusively to basic lines, which are enough to display the elegant qualities that are inherent to this medium.

Drawing with ink requires a steady hand, and this is achieved only with confidence and without being afraid to make mistakes.

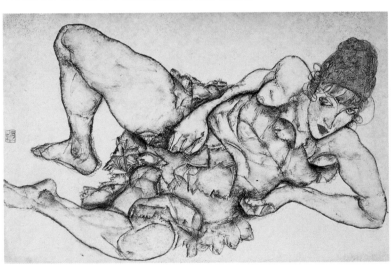

Egon Schiele, Blonde Woman in a Reclining Position. The Baltimore Museum of Art (Baltimore, MD). A good sketch can be worked on until it becomes a true masterpiece, as is the case in this ink and watercolor drawing.

Ink drawings vary considerably, depending on whether the lines have been drawn with the front or the back of the nib, and on the pressure applied by the hand.

Drawing with Colored Ink

Although colored ink is not a very stable medium because it eventually fades from continuous exposure to light, it can be used perfectly for drawing because, unlike work that is based on areas of color, this factor does not have much effect on fine lines. This theme involves the figure of a child. The girl's clothing suggests a playful and happy attitude. The procedure used introduces lines of different colors and a very unusual approach, consisting of the sporadic and liberal application of color throughout the drawing to give the piece a festive feeling.

MATERIALS
- Smooth drawing paper
- Metal nib
- Blue, red, yellow, and green ink
- Dip pen and sanguine ink
- Flat, soft-hair brush

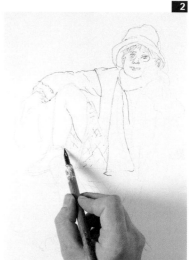

1 The figure is loosely sketched with a hard-lead pencil that will serve as the guideline so the ink can be applied with confidence. The first contours are drawn with the dip pen and sanguine ink. Every feature and detail is based on simple lines, without too many of them in one single area.

2 The areas of less relevance are drawn with lighter colors, such as this yellow one used to create the contour of the leg. Work must be completed quickly and without paying too much attention to detail. The spontaneity of the lines depends on the hand's agility.

3 To ensure the graphic interest of the work, the drawing should alternate areas of great detail and accumulation of lines with empty areas. In this case, the scarf and the sweater fulfill that purpose presenting areas of multicolored dots and lines of different intensities.

MIXING INKS
Colored inks can be mixed with each other. If this is done, we recommend limiting the amount of the darkest ink so as not to overwhelm the general feeling of the drawing or even completely cancel out the lightest color.

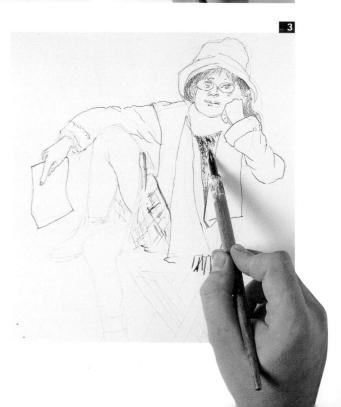

TECHNIQUES USED
◆ Blocking in the figure ◆
◆ Adding interest with ink ◆

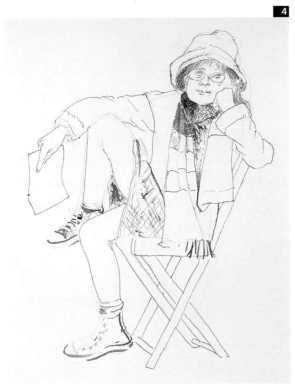

4 The drawing of the figure is completed. From this point on, the work consists of adding details and contrast with lines and color to enrich and define the clothing.

5 It is normal for ink to drip by accident during the drawing process. These mishaps can add visual interest and it is worth taking advantage of them. A few lines and blocks of wet ink have been added using a soft-bristle brush. This has contributed to the happy mood of the subject.

6 After adding paint liberally around the area of the chair to ground the pose, the drawing can be considered finished. This exercise shows the possibilities of ink when the work is approached with confidence and flexibility. The lines provide a visual interest that is beyond their simple representative function, and the overall feeling of spontaneity would be impossible to achieve by any other means.

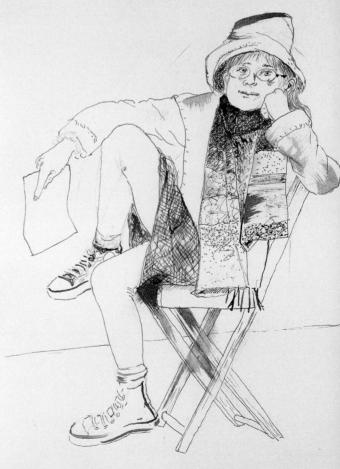

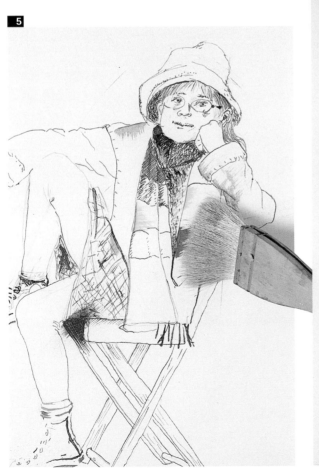

Chalks and Pastels

Pastels are sticks of dry paint bound with a small amount of gum arabic, which provides adhesion to the paper. Chalks are smaller sticks, long and square in shape, and quite a bit harder than pastels. Traditionally, this name is given to white, black, sepia, and sanguine-colored bars. These media have been used since the Renaissance for adding light coloration to drawings, although the effect is based more on tonal contrast than on color.

Many artists combine both methods in the same drawing. They use pastels to apply large areas of color, while using chalk to define the contours and add details. Pastels are basically limited to coloring and can be used quite liberally. They are good for shading and blending large areas, as well as for the most impressionist techniques based on details of pure color.

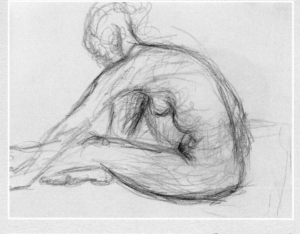

Two examples of a project done with pastels more resembling a drawing than a painting.

Soft pastels produce thick lines that do not have much precision, but their color is richer than hard pastels (or chalks). Besides, the areas of color can be spread easily with a finger or a rag.

The Color of the Support

The most common support for pastels is textured paper (but without too much texture). Most artists working with pastels, and especially those who draw the human figure, use papers in a color that enhances the overall harmony of the work. Logic dictates selecting warm tones (soft green, pink, sienna, soft mauve, soft ocher, and so on), depending on the color chosen for the skin. This type of surface allows the artist to work with a range of colors chosen accordingly, letting the color of the paper come through the blocks of pastel colors.

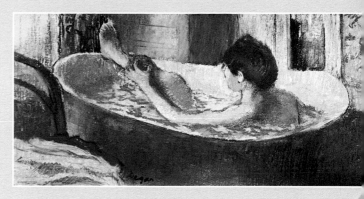

Edgar Degas, Woman in the Bathtub, Musée du Louvre (Paris, France). Pastels are a quick medium to work with and produce great quality results. This method can be classified as being somewhere between drawing and painting.

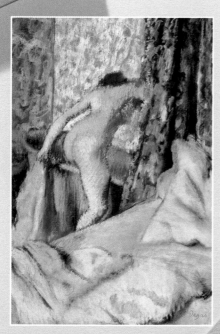

Edgar Degas, The Morning Bath, The Art Institute of Chicago (Chicago, IL). A masterpiece in its genre, where the cool tones give almost a monochromatic feeling to the scene.

Pastel pencils allow the artist to work in almost the same way as with colored pencils, but with much more color saturation.

Drawing of a Male Nude with Pastels

The question of whether pastels are a drawing technique or a painting technique is a matter for the artist to decide. Lines and masses of color are compatible (and equally expressive). Whether line features should dominate over color, or vice versa, will be a question that the personality of the pastel drawing will answer. This exercise, a painting of a male nude, is based on masses of color rather than line. However, the preliminary steps of the project were laid out with lines.

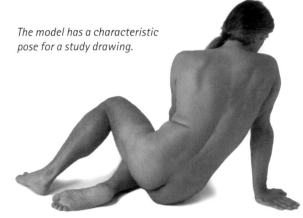

The model has a characteristic pose for a study drawing.

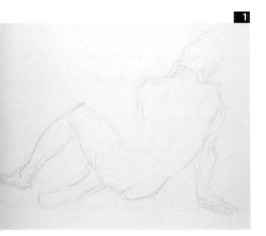

1 Preliminary pencil drawing that establishes the guidelines to avoid mistakes. It consists of simple contour lines, which highlight the main anatomical features.

2 The pencil lines are redrawn with a stick of sienna pastel; the areas to be shaded are identified with a few quick lines.

MATERIALS
- White drawing paper
- Burnt sienna, gray, white, ocher, and light blue pastels

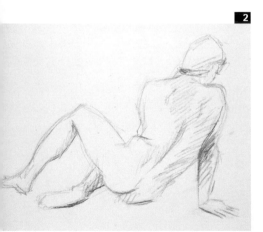

3 After the shaded areas have been highlighted with a sienna stick, a few white lines are added over them. Both colors are mixed directly on the paper, hiding the few sketch lines and producing a color that resembles the tone of the skin.

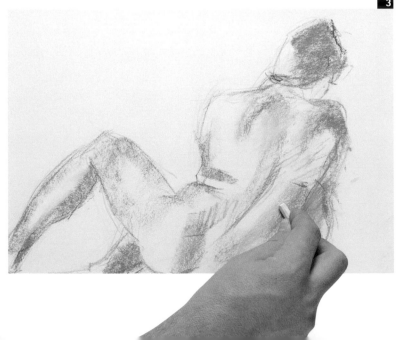

TECHNIQUES USED

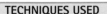

♦ Blocking in the figure ♦
♦ Shading ♦

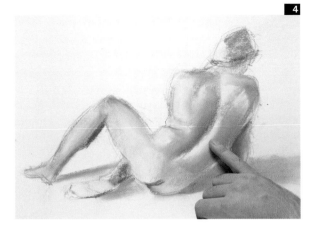

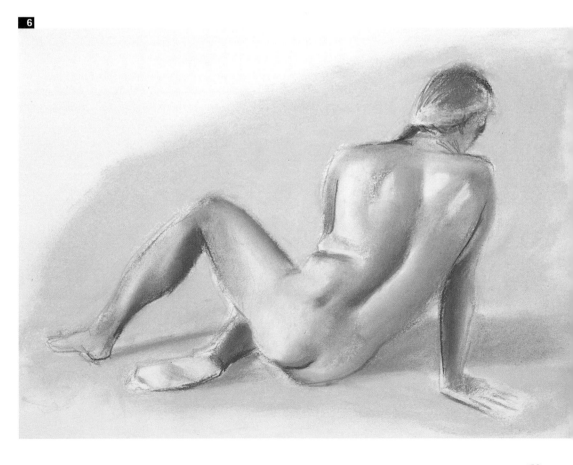

4 After drawing many lines with a sienna pastel, with or without white shading, the area is rubbed with a finger to achieve the perfect integration of each anatomical feature. The shading is reinforced in the most relevant areas, such as the indentation along the spinal cord, the calves, the arm, and so on.

SHADING OR NOT

Shading expands the colors, eliminates the lines, and consolidates the texture of the pastels. Some artists prefer not to use it because they like the effect of the marks left by the pastel stick on the paper. The artist has the final word on this matter, which must always be guided by the personality of the work.

5 Gray shading clearly suggests the direction of the light as well as the surface of the floor on which the figure is reclining. This special feature is reinforced by the tone of the background around it.

6 The cool blue tone contrasts very vividly with the warm color of the flesh and highlights the drawing as well as the color of the figure.

Watercolors and Other Wet Techniques

Wet techniques are those that require water to dissolve the paint, such as watercolors, washes, gouache, and so on, or any other mixed technique that can incorporate water solutions (drawing on a base of wash, ink washes, etc.). All these procedures use the brush as the preferred tool for application. Among them, watercolor stands out as the best medium. It provides a sophistication and luminosity that cannot be compared to anything else, and is particularly attractive for painting the human figure, especially nudes and sketches.

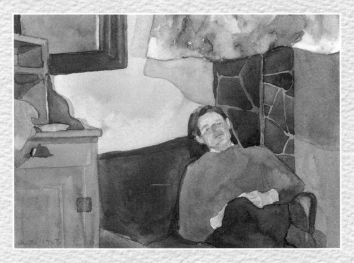

Watercolor by Mercedes Gaspar. This work, of great chromatic intensity, shows the extraordinary richness and warmth that can be achieved with watercolors.

Good-quality watercolors are available in tubes and in small containers, where the paint can be mixed quickly by rubbing a wet brush in it.

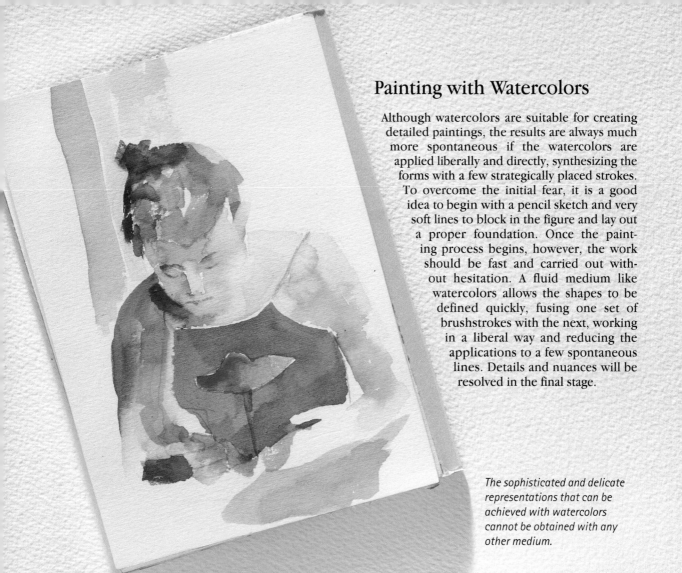

Painting with Watercolors

Although watercolors are suitable for creating detailed paintings, the results are always much more spontaneous if the watercolors are applied liberally and directly, synthesizing the forms with a few strategically placed strokes. To overcome the initial fear, it is a good idea to begin with a pencil sketch and very soft lines to block in the figure and lay out a proper foundation. Once the painting process begins, however, the work should be fast and carried out without hesitation. A fluid medium like watercolors allows the shapes to be defined quickly, fusing one set of brushstrokes with the next, working in a liberal way and reducing the applications to a few spontaneous lines. Details and nuances will be resolved in the final stage.

The sophisticated and delicate representations that can be achieved with watercolors cannot be obtained with any other medium.

Charles Demuth, Circus. The Smithsonian Institution (Washington, D.C.). An alternative way of using watercolors to represent the human figure. The colors are delicate and soft.

Sketching with Watercolors

The materials for watercolors can be as easy to carry as those for drawing, if they are reduced to a minimum. The only elements needed to sketch outdoors are a small sketchbook, a small box of paints (there are pocket versions), and a small container for water (which can be small enough to fit into the box). These simple tools allow the artist to work outdoors, in the street, in a park, or even at home, to capture spontaneous scenes very quickly and without the technical complications associated with working in a studio. Quick sketches can be done with a limited number of colors, even with a single one. If the theme allows, the artist can spend some time developing the color and the details of the scene.

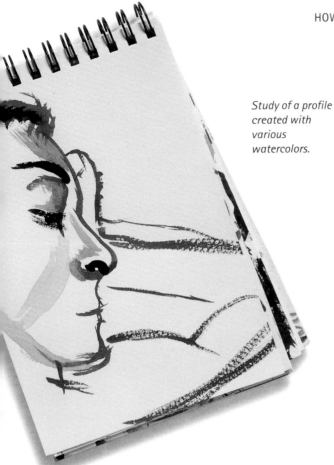

Study of a profile created with various watercolors.

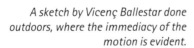

A sketch by Vicenç Ballestar done outdoors, where the immediacy of the motion is evident.

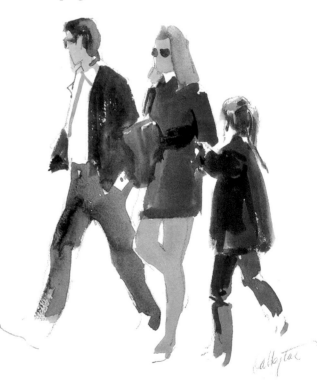

The quickness and freshness of watercolors is enhanced by the unusual format of this work and by the clever composition of the space.

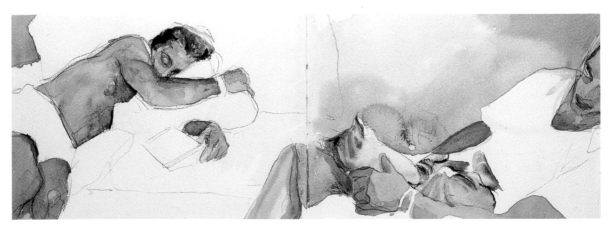

Drawing with a Brush

A brush is a drawing tool that is suitable for creating studies, sketches, and notes outdoors. The impression of the line is counterbalanced by the freshness of the results. The immediacy and spontaneity of watercolors are hard to achieve with any other medium. The flexibility of the brush's bristles produces different line thicknesses; therefore, it is more appropriate to talk about brushstrokes and blocks of color than of lines. Notes and sketches made with watercolors do not require many tools, but they do require knowing how to synthesize. It is best to use only one or two colors and to do it very sparsely; too many lines and colors ruin the results.

This sketch captures a person walking the same way a photograph would.

MONOCHROMATIC PAINTINGS
Monochromatic paintings involve only one or two colors at the most; more colors than that would end up mixing on the paper and ruining the shapes of the figures. This color limitation is compensated for by the tonal variations that result from adding more or less water to the solution. Saturated colors are used to highlight the main lines or the shaded areas, while the softest contours are defined with a very diluted, almost transparent, mix.

Here is a quick sketch done in a small sketchbook that captures a spontaneous moment with the help of color alone.

George Bellows, Under the Elevated Passageway. *The Museum of Modern Art (New York, NY). The great vitality of this scene has been achieved by minimizing color and simplifying the drawing to the extreme.*

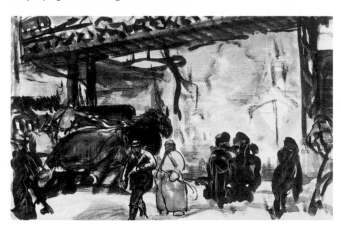

Drawing of a Woman's Back with Watercolors

Watercolors are very appropriate for painting figures, whether a sketch, a study, or a more elaborate drawing. This exercise is in the latter category. The results, however, are almost as fresh and spontaneous as those in a sketch. The colors are direct, the applications large, and the brushstrokes are very soft.

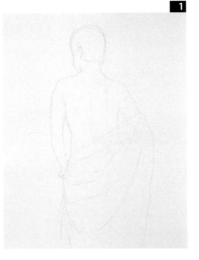

Despite the fact that this figure is posing, the painting style is spontaneous, without too much detail. All the requirements of the work can be achieved with simple applications of more or less diluted color.

MATERIALS
- Medium-grain watercolor paper
- Watercolors: burnt sienna, carmine, ultramarine blue, cobalt blue, and burnt umber
- Medium, round brush made of ox hair, and a small, flat, synthetic brush

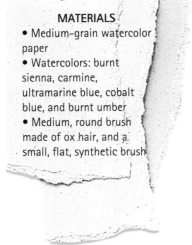

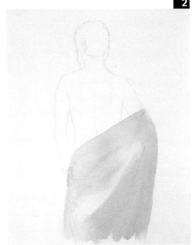

1 It is never a good idea to overwork the preliminary drawing for a watercolor. In this example, the sketch consists of a few contour lines that suggest the lines of the body.

2 A large mass of diluted carmine color suggests the first stages of the cloth. It is best to begin this process with the darkest tones and to continue lightening them progressively with a brush loaded with water.

3 The initial skin tones are applied in exactly the same way as the cloth. A few blocks of paint lightly dissolved in water will be spread and defined with the wet brush until the perception of volume is achieved.

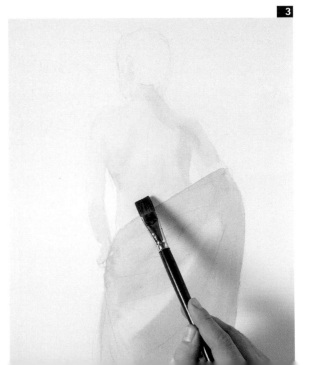

TECHNIQUES USED

◆ Blocking in the figure ◆
◆ Washes ◆

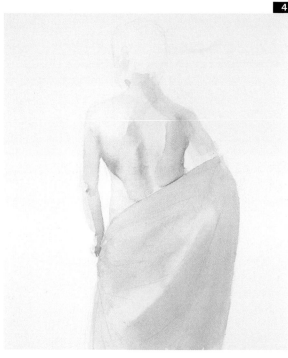

WET ON WET
To lighten an area of watercolor, simply brush over the wet paint with a brush dipped in clean water. The color will become lighter as the process is repeated.

4 The line between the skin and the cloth has been carefully respected to make sure that one area did not invade the other and ruin the effect. Once the basic volume is defined, the rest is simple; the only requirement is to intensify the shadows, leaving the lighter areas untouched.

5 The background is created with ultramarine blue (a very cool tone), which will very clearly define the contours of the figure. The contrast between the background and the warm and cool tones of the figure, or the light and dark colors, highlights the effect of the watercolors.

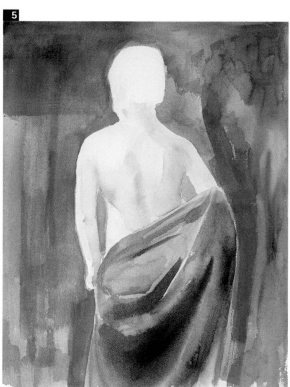

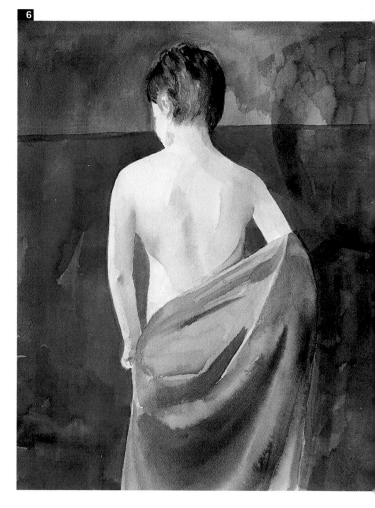

6 To complete the project, the shadows of the folds and the figure's head are darkened, leaving the rest of the flesh as it was at the beginning. The contrast between cool and warm tones and values takes care of the rest.

Oil Painting

Oil painting is one of the most important art media; the majority of the famous figure paintings are done with oils. The chromatic density and the richness of oils have no equal. Traditionally, these qualities have been used to capture the subtleties of the skin; the pink and pearl-like tones can be created with oil paints. In addition to the great possibilities that oil paints offer when representing scenes from nature, they have the particular property of adapting to the artist's requirements. They produce great results, whether it is a very detailed and delicate painting or just a simple project.

Chiaroscuro

Chiaroscuro is a technique that encompasses very marked contrasts of light and shadow. Oil paints lend themselves to this technique better than any other medium, and chiaroscuro produces its best dramatic results in figure painting. A figure that displays a strong contrast of light has a special sense of expression, which can be either dramatic or intimate and quiet. The direction of the light and its reflection produce, through a combination of tonal values, the most refined effects, which become the main focus of the painting.

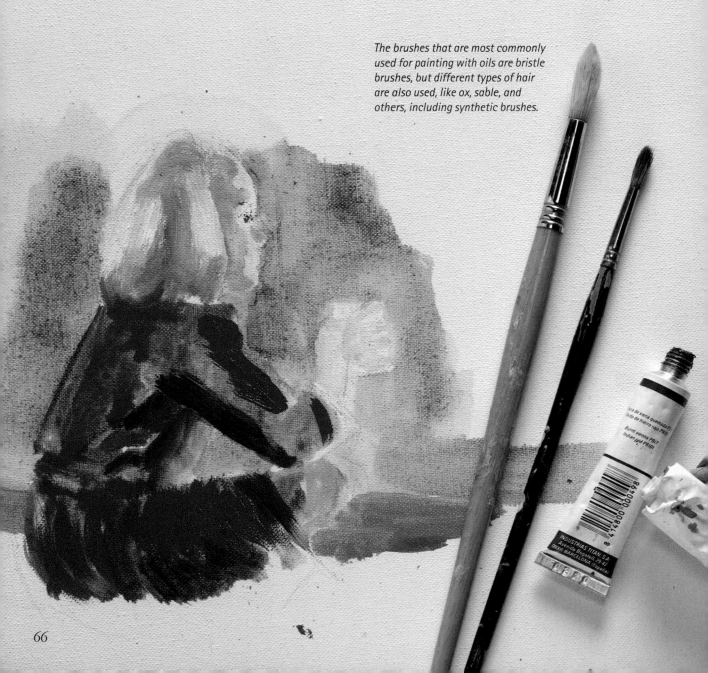

The brushes that are most commonly used for painting with oils are bristle brushes, but different types of hair are also used, like ox, sable, and others, including synthetic brushes.

SKIN COLOR

Skin does not have a definite tone; it is always affected by the light that surrounds the figure. Skin tones are usually warm colors, shaded by the cool tones of the shadows, which can be either green or blue. Oil paints are very suitable for creating full and rich skin tones, thanks to the great possibilities that they offer for mixing.

IMPASTO

Impasto consists of applying thick layers of paint, to the point where the surface of the canvas acquires a very rich texture. The sticky consistency of oil paints and their slow drying process make it possible to extend this quality to surprising limits. In figure painting, impastos are used for the areas with the brightest or richest colors (areas of light, warm skin tones, clothing, and so on).

Jean Diego Mambruie, Oil Sketch. Private collection. A painting that combines the immediacy of the sketch and the inherent qualities of oil paints in a composition full of interesting ideas.

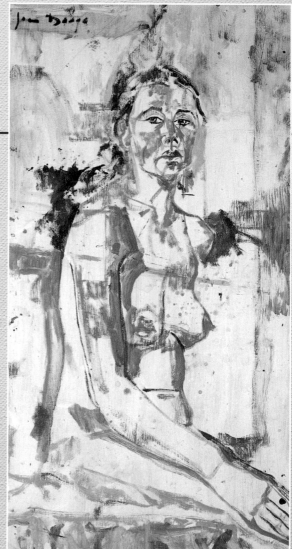

Oil paints are available in tubes of various sizes. It is a good idea to purchase large tubes of white and black paint, which are the most frequently used.

Quick Sketches

Although traditionally oils have been used for very elaborate paintings, they are also suitable for quick works. Oil paints, diluted with a solvent, can be used the same way as watercolors, although they will never be as luminous and transparent. Toulouse-Lautrec used to paint figures with a variety of colors that were very diluted with mineral spirits and were later touched up with a few applications of thick paint to produce a vivid contrast. In any case, this quick and spontaneous technique is very suitable for painting urban and busy scenes, with the added advantage that the work can be touched up as needed once the initial effect of freshness and spontaneity has been established.

THE IMPORTANCE OF THE BRUSHSTROKE
Regardless of the style that the artist is using with oil paints, the brushstroke is always of vital importance. It produces a rhythmic and dynamic effect in quick works, and it gives life to the surfaces that are filled with color in slow processes, preventing them from looking flat and lifeless. The brushstroke is always the direct result of a personal style, which is why it gives the painting personality and character.

DIFFERENT SUPPORTS
Oil paint, used as a drawing medium with a brush, can be used on supports such as paper and cardboard, as long as they are properly sealed with a primer (gesso is the most common) to prevent the oil from staining the support.

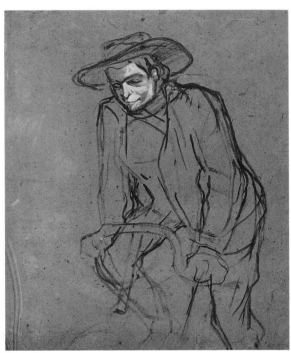

Toulouse-Lautrec, Bruant on a Bicycle. *Musée Toulouse-Lautrec (Albi, France). A line drawing appropriate for the dynamics dictated by the theme, in which oils have been used more as a drawing than a painting method.*

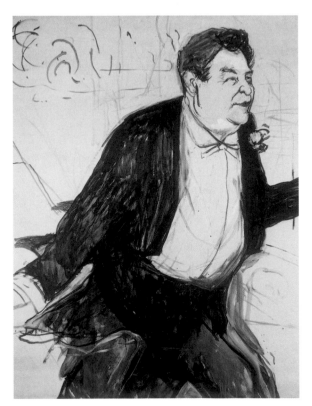

Toulouse-Lautrec, Figure in Motion. *Musée Toulouse-Lautrec (Albi, France). In this simple oil painting, a powerful feeling of movement has been created with its spontaneity and by placing the figure off center.*

Figure Painting Exercises

Although we have seen some examples of figure drawing and painting in the previous pages, this section includes a follow-up to the process of planning and executing the different figure painting techniques.

This chapter presents several practical exercises that include different figure painting solutions. The methods used range from techniques with colored pencils to watercolors, pastels, and oil paints. Each one of these techniques shows the capabilities that the medium offers to work a scene spontaneously or in detail. The exercises that we propose are based on the assumption that you already know the basic aspects of

Each one of the exercises is based on the assumption that you know the basic aspects of drawing, especially how to block in the figures.

drawing, and especially how to block in the figures. This procedure does not require a great knowledge of anatomy but the ability to sketch the overall figure with the correct proportions and some degree of competency. The examples include both clothed and nude models, which in some cases reach the status of portraits. Each one of the exercises is shown in detail and every important action of the artist explained.

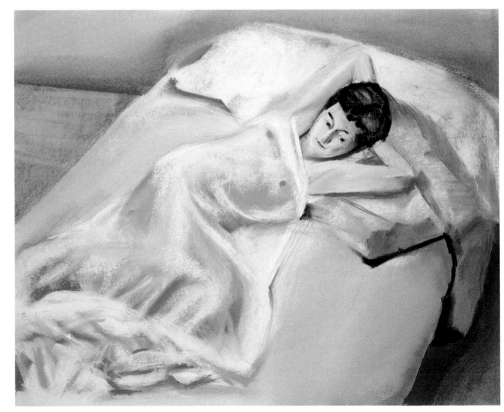

This section of the book contains practical exercises, paying special attention to the art techniques employed by professional artists in their compositions.

Studies of Figures in Motion with Colored Pencils

Drawing figures in motion requires a quick, simple, and direct technique. There is no time for complicated mixtures or preliminary planning. Pencils in general, and colored pencils in particular, perform very well in capturing movement, not only for the spontaneity that the medium offers, but for the character of its lines. Pencil drawings are dynamic and quick, especially if the work is sketchy, without too many details. This exercise by D. Sanmiguel comprises three different aspects of the same theme, the last being a view of the completed work.

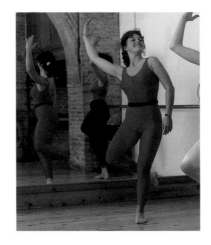

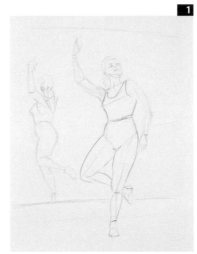

A ballerina and her reflection in the mirror represent two different figures for the artist—two points of view of the same movement. This is an excellent opportunity to practice drawing figures in motion. The balance and coordination of the arms and legs is a major factor, whose secret consists of quickly capturing and defining the gesture and pose of the balanced body.

MATERIALS
- White drawing paper
- Cadmium red, vermilion, ocher, burnt sienna, light blue, pink, mauve, gray, burnt umber, and black colored pencils
- Graphite pencil
- Eraser

1 Blocking in the figure (or figures) is done by using the proper diagrams for every part of the body.

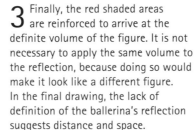

2 The volume of the body is quickly filled in with colored lines, without regard for any aspects of modeling. It is important for both figures to show the same movement, so they can be interpreted as a ballerina and her reflection in the mirror.

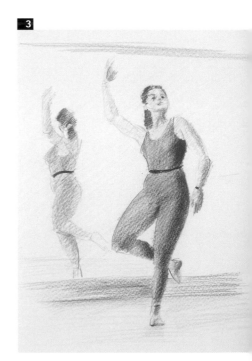

3 Finally, the red shaded areas are reinforced to arrive at the definite volume of the figure. It is not necessary to apply the same volume to the reflection, because doing so would make it look like a different figure. In the final drawing, the lack of definition of the ballerina's reflection suggests distance and space.

TECHNIQUES USED
- ◆ Blocking in the figure ◆
- ◆ Movement ◆
- ◆ Pencil drawing ◆

Dynamic Balance

A seated figure is in perfect balance. It is a static balance in which the points of contact are more than sufficient to keep the stability of the body. There is another balance in which the contact points are less efficient: dynamic balance. In this type of balance the resting points are as important as the distribution of the weight; the slightest change in the distribution will make the body fall. The aim of this drawing is to counterbalance the way the arms and legs move and turn to create the feeling that the figure is standing on her foot.

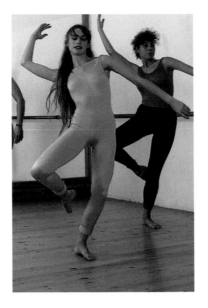

This is a balanced movement, not a transition between two movements as would be the case with running or walking. Normally, a ballerina would be able to remain in this position for a short time. Therefore, the key for this pose is to block in the figure in this delicate balance. It must look like the girl is really standing firmly on one foot.

1 Blocking in this figure is the most difficult part of the process. The balanced pose must be captured from the beginning. The first shades are applied using the light blue pencil to make the volumes more visible. This shade must be very light, to maintain the overall effect.

2 The modeling is reinforced little by little, using darker and warmer tones (with a burnt umber pencil) that define the ballerina's blue leotard.

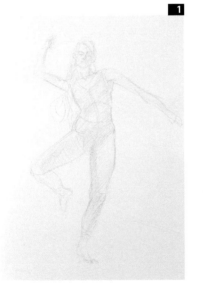

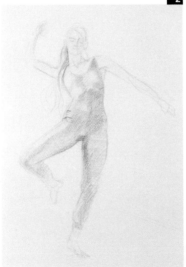

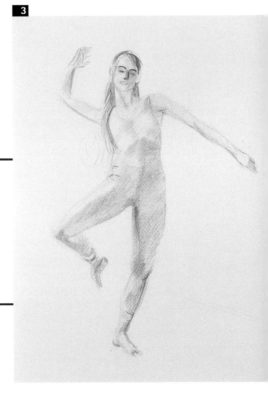

MOVEMENT AND EXPRESSION
A common mistake among beginners is to overwork the facial expression of the figures in motion. Doing this makes the features appear frozen in an awkward gesture. Like everything else in a moving body, the facial expression is a secondary factor that should not attract too much attention. Suggesting the correct placement of the features is sufficient, without spending too much time trying to achieve an unnecessary resemblance.

3 Beginning at the center of the figure, the light shades extend outward to the arms and legs. Important anatomical features, such as the breasts, the arching ribs, and the pelvis, can be perceived underneath the leotard. It is important to draw them faintly to achieve the effect of muscle tension.

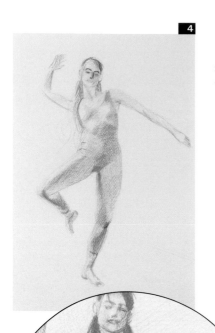

4 The shading combines cool and warm tones that create a slightly silvery gray effect, which lightens the contours of the figure.

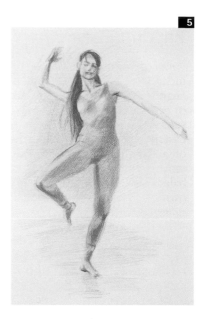

5 The definition of the forms created through shading does not disturb the delicate movement of the figure, which is the true focus of this exercise.

6 The last touches consist of softening the transition between areas of light and shadow by applying a little bit of color to create intermediate tones that solidify the volumes, without making them too heavy.

7 Finally, the facial features are erased slightly to divert attention away from them. Movement is the central focus of the exercise and any other aspect is secondary.

Rhythmic Movements

Finally, we will deal with the complete scene, which includes a total of three figures. The most important factor now, along with movement, is the placement of each person in the scene, and the distance that separates them. Once this is established, it will be easier to achieve the desired effect: the composition of a multiple rhythmic ensemble in which each movement has individual meaning. The gestures and balance of each figure have a personality of their own (a particular musical rhythm) and that must be reflected in the drawing.

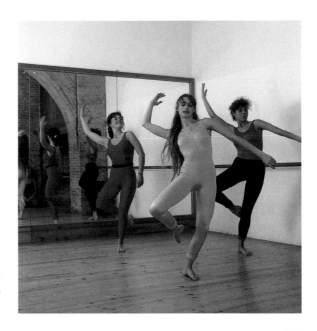

This illustration shows the entire scene, two details of which have been worked out previously. The group of figures follows the same rhythm, and reflecting that rhythm is the final goal of this exercise.

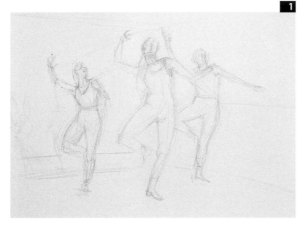

1

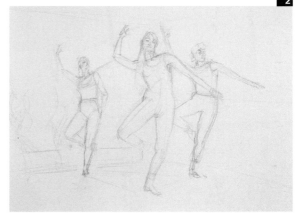

2

1 Although the proportions of the figures have been established, the drawing still does not have a rhythmic coherence. It is easier to notice this aspect than the individual mistakes, so once the artist becomes aware of it, it is easier to identify the problem.

2 Some corrections have been made here, for example, the positions of the legs. It is very important to establish the sizes of the figures, so each one of them is correctly placed in relation to the others.

3

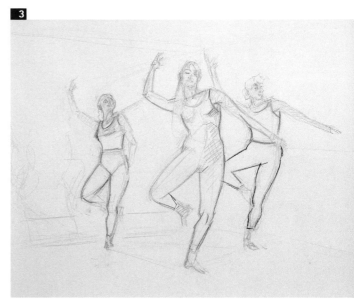

3 It becomes apparent now that the problem was the figure on the left, whose size was exaggerated with respect to the figure in the middle. Reducing its size and placing the feet on a higher plane made the three figures fit more coherently within the composition.

4

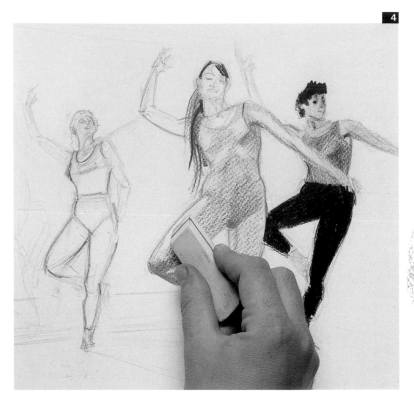

4 Now color can be applied, the same color and treatment seen in previous exercises, although more sporadic than before so the scene does not appear overworked. Precisely for this reason, an eraser is used in the areas where the color tones are softer.

THE BACKGROUND

In drawings that represent movement, the description of the background does not need to be too precise. In fact, a loose and sketchy background contributes to the final effect and makes it look as if the figures were really moving.

5

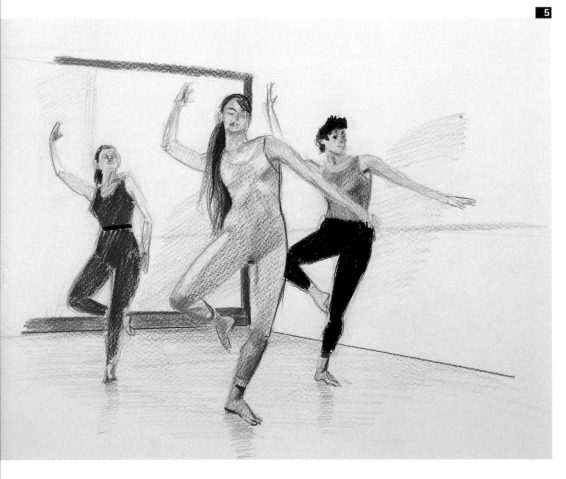

5 This is the final drawing that has resulted from following the procedures learned so far. Each figure has a correct balance and together they reflect a rhythmic unity.

Drawing the Figure with Markers

Markers are a modern version of dip pens and reed pens. The principle is the same: a point that dispenses ink onto the paper. The main difference is that markers hold the ink inside and that the point is soft and makes continuous and consistent lines. Here, Oscar Sanchís uses a double-tip marker (one at each end); one point is flat for wide lines, and the other round and pointed for fine lines. In this case, the ink has an alcohol base and its transparency makes color layering possible.

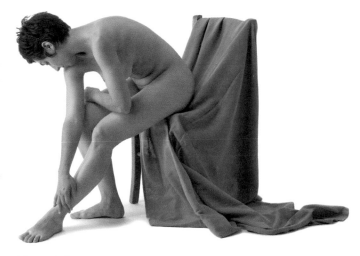

The model's pose creates an interesting play of light and shadow on the body, which will be worked out with lines and overlaying colors.

MATERIALS

- A range of alcohol-based markers
- Smooth paper for ink
- Medium-hard graphite pencil
- Eraser

1 A general diagram is drawn first to block in the figure, including the basic proportions and the main angles (leg, back, forearm, etc.). This diagram is drawn with the simplest possible lines.

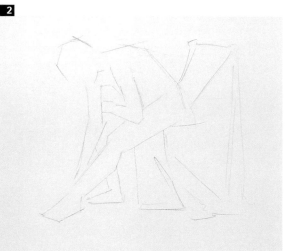

2 When the basic angles and distances are established, the anatomical features are drawn in greater detail. The drawing, when finished, must be erased until the pencil lines are almost completely eliminated.

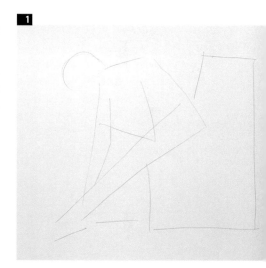

TECHNIQUES USED

◆ Blocking in the figure ◆
◆ Ink drawing ◆

3 The softest tones are applied first (pink or another soft color), creating crosshatching that covers the figure as if it were a layer of paint.

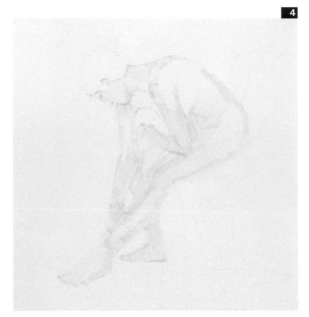

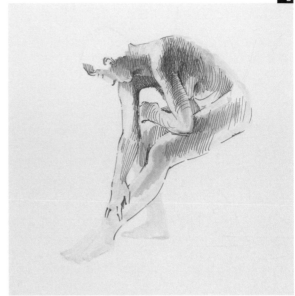

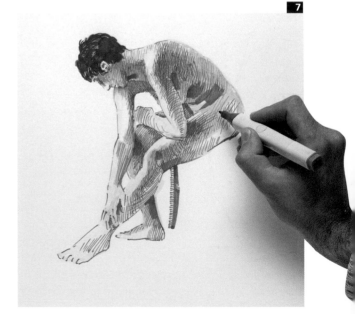

4 The areas corresponding to darker colors have been left blank, and they will be covered later with wider lines.

5 This illustration shows the darker areas, which now occupy the parts that were left blank before. This new color has been applied with the marker's tip, which is wide and cut at an angle. These new lines have been created with the same marker but using a finer point. The arms and legs have acquired more volume with the crosshatching.

6 A new color, darker than the one used before (a darker sienna), helps highlight the areas of the body with more light by darkening the more shaded areas.

7 New crosshatching is applied with the same color used before to define the previously colored areas, using the wide tip of the marker to soften the light and shadow contrasts. Also, the hair has been painted in a darker tone.

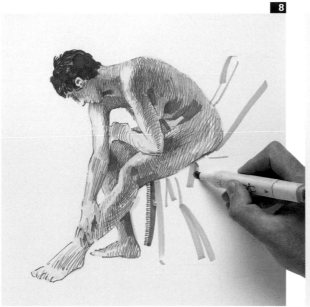

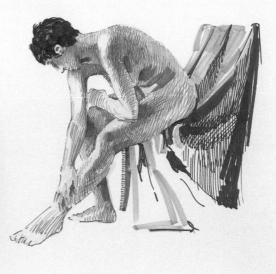

8 The cloth covering the chair can now be painted with a medium tone, similar to the ultramarine blue used in the drawing. In this case the color has been applied with broad lines, using the wide tip of the marker.

9 The folds of the cloth have been indicated with a darker blue using wide lines depending on whether the area is in light or shadow.

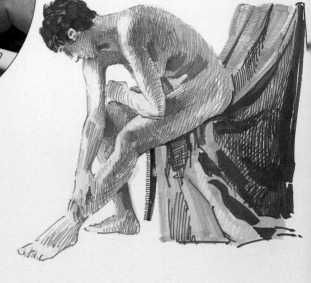

DRY MARKERS
Markers that have dried out make less consistent lines, similar to those created with a reed pen that is almost running out of ink. This type of marker does not produce continuous lines but the textures created this way enrich the graphic appeal of the project.

10 While the cloth was being painted, the figure has been modified as well. Cooler tones have been introduced to give more definition to the skin and more contrast to the areas of light and shadow, especially along the left leg.

11 Sometimes, as in this case, it is important for the lines to produce the effect of a block of color. This is achieved by drawing the lines closer together until they run into each other.

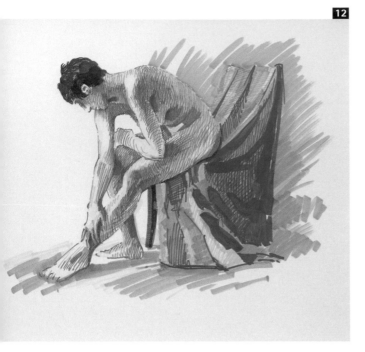

12

COMBINATIONS OF LINES

The intensity and color of the lines that can be created with markers depend on the width of the tip. In this exercise, two different widths have been combined to achieve different textures and areas of chiaroscuro.

12 The figure is practically finished except for a few touches and nuances that can be introduced here and there, but that will not change its general appearance.

13 The wide lines of the background give a finished quality to the drawing and also make the figure stand out against the white paper, which would otherwise be too monotonous.

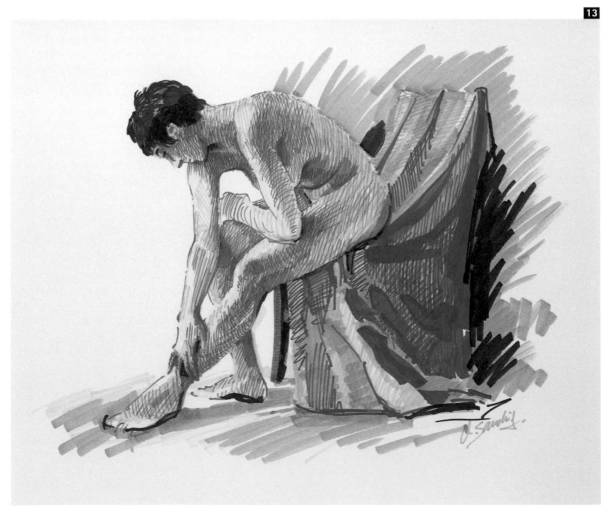

13

Drawing and Color in a Watercolor Figure

This exercise by David Sanmiguel shows a peculiar way of painting with watercolors that has little to do with the traditional style established for this medium. It consists of a detailed preliminary drawing done with charcoal. The drawing is respected through the entire process and the color (of moderate intensity and spread over large areas) is applied within the confines of the drawing. The result is fresh and uninhibited in one way, similar to an illustration, and in another like colored drawings resembling a sketch or a small study.

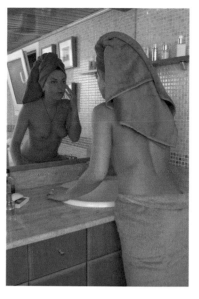

MATERIALS
- Fine-grain watercolor paper
- Burnt sienna, yellow ocher, cobalt blue, and Hooker green watercolors
- Synthetic hair medium flat brush and fine, sable hair round brush
- Charcoal stick
- Rag
- Eraser

This is a scene known as a toilette, which is a term that describes the genre that became popular as a result of some Impressionist paintings of powder room scenes. It represents the back view of a woman whose image is reflected in the mirror. The female back, as an anatomical feature, and the reflection as an anecdotal subject, are the two factors that will be involved in this painting.

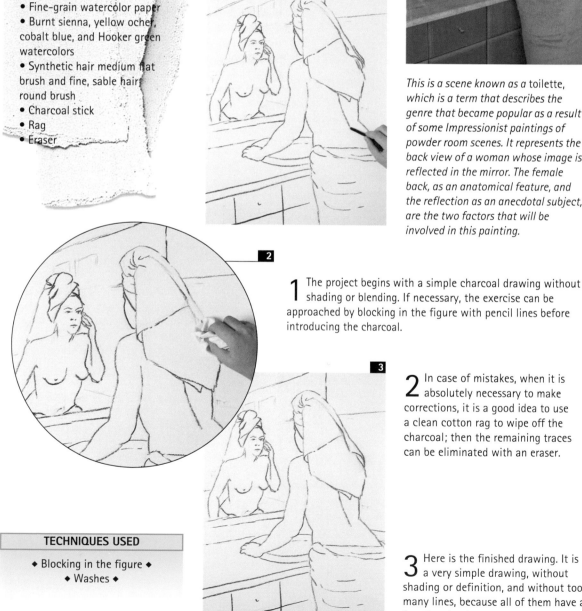

1 The project begins with a simple charcoal drawing without shading or blending. If necessary, the exercise can be approached by blocking in the figure with pencil lines before introducing the charcoal.

2 In case of mistakes, when it is absolutely necessary to make corrections, it is a good idea to use a clean cotton rag to wipe off the charcoal; then the remaining traces can be eliminated with an eraser.

3 Here is the finished drawing. It is a very simple drawing, without shading or definition, and without too many lines, because all of them have a functional value.

TECHNIQUES USED

◆ Blocking in the figure ◆
◆ Washes ◆

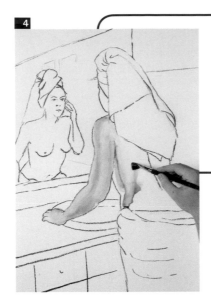

4 The figure is modeled by varying the intensity of the brushstrokes, which are very dark soon after they are applied, but as more water is added, the figure becomes lighter along the trajectory of the brush.

CHARCOAL AND WATERCOLORS
Many watercolorists use charcoal for sketching their compositions; however, in this exercise, the sketch is a finished drawing in itself. Watercolors get dirty when they are mixed with charcoal, but the artist can use this factor to create harmony, in which the "dirty" colors enhance the overall feeling of the work.

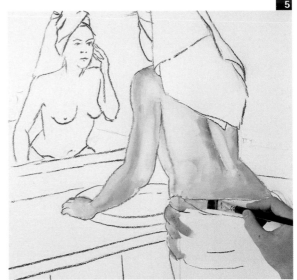

5 The spine is created by applying a long brushstroke of thick, undiluted paint. The same color diluted is used to paint the contrast that defines the volume of the body.

6 The towel has been created by mixing Hooker green with a small amount of sienna color. It is applied the same way as the skin: first the denser color for the darker areas, and then the same color diluted in water for the remaining areas outlined by the drawing.

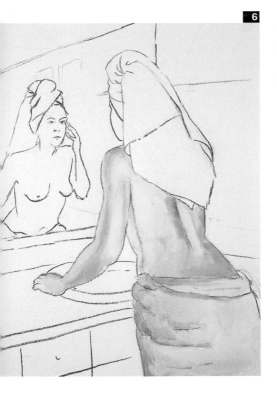

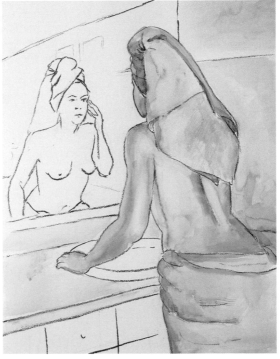

7 Now the background is created. A large wash of ocher and sienna, very diluted with water, is spread over the entire wall. This tone is very similar to the figure's skin, which creates the general harmony of the painting.

8 The background has been painted almost completely. Even the reflection in the mirror has the same colors. This way, the reflection does not become the primary focus of the picture, or a different figure, but a real reflection.

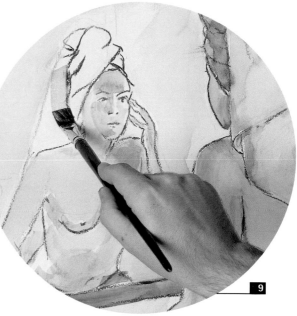

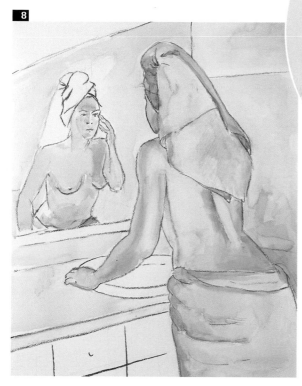

9 All the areas of the reflection have been painted with the colors used for the figure, although they are more diluted and contain a larger proportion of sienna.

10 Now the colors of the background are adjusted by darkening certain areas and creating slight contrasts on the surfaces and their reflections in the mirror (the color of the reflection should be slightly darker).

11 The secondary details can now be introduced: the bottles, the mirror's frame, the drawers, and so on. Here the colors can be brighter, because the overall composition has already been established.

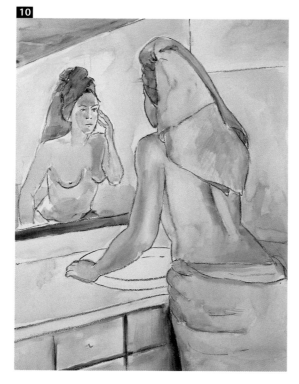

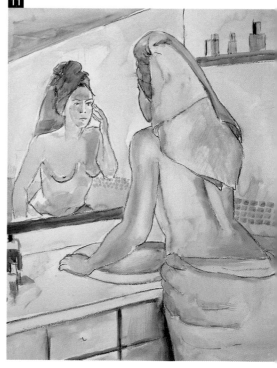

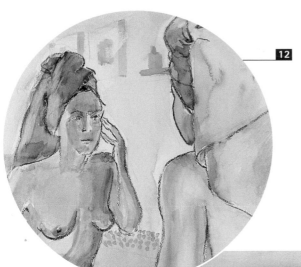

REFLECTIONS AND LIGHT

The objects and their reflection in the mirror can be set apart by the intensity of the light. This figure appears to be lit from the back, therefore the reflection will look darker because the area with less light is the one facing the mirror. This difference must be stressed to achieve a convincing effect.

12 The composition's background includes several light brushstrokes suggesting the decorative details, which create a feeling of space. It is extremely important that the color used for this purpose be very light to achieve a convincing effect.

13 Here is the result—a watercolor that is simple and fresh, in which the medium has been used without great complication. The effect is very appealing and completely convincing from the anatomical point of view. The colors are also very suggestive.

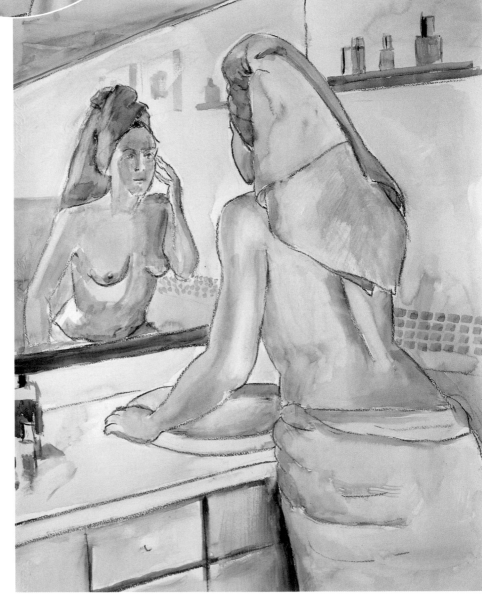

The Figure in a Classic Watercolor

In this exercise, Vicenç Ballestar will execute an outdoor scene according to the stylistic dictates of a classic watercolor. The development and results are characterized by a complete mastery of light and shadow, and a remarkable realistic likeness.

The resolution of light and shadow is a very important factor in this outdoor scene. In fact, the vitality of the entire scene depends on the manner in which these two components play against each other.

MATERIALS
- Graphite pencil
- Ocher, Hooker green, raw sienna, ultramarine blue, and cadmium yellow watercolors
- Sable hair brushes
- Medium-grain watercolor paper

TECHNIQUES USED
- ◆ Blocking in the figure ◆
- ◆ Washes ◆

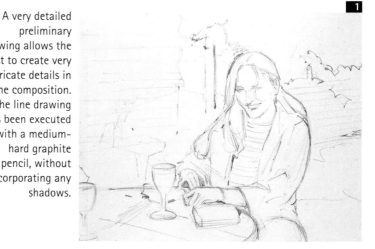

1 A very detailed preliminary drawing allows the artist to create very intricate details in the composition. The line drawing has been executed with a medium-hard graphite pencil, without incorporating any shadows.

2 An overall ocher wash will represent the wall in the background, which is behind the figure. This wash has been shaded in certain areas to suggest from the very beginning the color differences of the wall.

3 Another large area of color (a mixture of Hooker green and ocher) creates a base for the vegetation. Just as with the ocher, here the wash also has different tonal intensities.

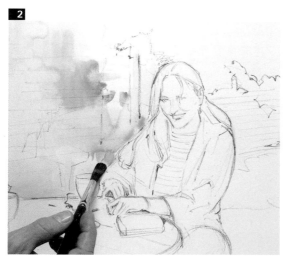

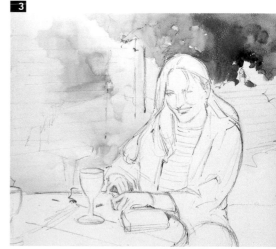

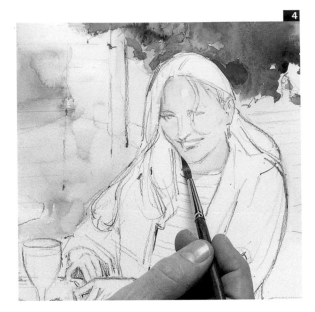

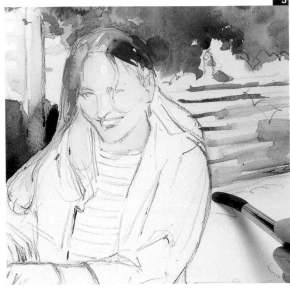

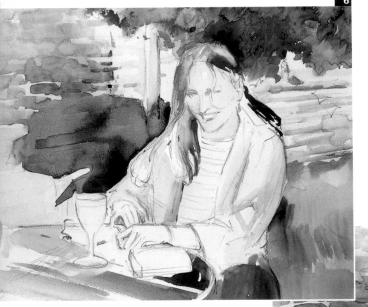

4 The figure is reserved, that is, left white against the painted background. This allows the purity of the skin tones and the clothing of the figure to be maintained. The pink facial tones are created with a very diluted red color.

5 The contours of the bricks in the background are outlined on a dry surface. This is done with the tip of the brush (using the sable hair round brush). The brushstrokes are applied liberally to avoid a static look.

6 The jacket is painted yellow with a few touches of sienna for the folds. The pants are pure ultramarine blue, and the table is raw sienna with touches of raw umber shadows, slightly diluted with water to suggest areas of light and shadow.

7 The few strands of hair that fall on the shoulders are defined with the thinnest sable hair brush, attempting to create the waves as precisely as possible.

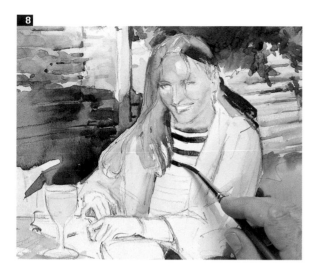

PAINTING LIGHT
Light must be represented with color, and specifically with color contrast. Contrast between cool and warm tones creates light effects; warm colors appear lighter than cool colors. Also, the contrast between dark and warm values suggests the intensity and direction of the light instantaneously.

8 The lines of the blouse are created with a mixture of ultramarine blue and raw umber, applying the color very densely to create a strong contrast between dark and light colors.

9 The wine in the glass highlights the strong and vibrant luminosity of the scene even more and creates a very rich play between light and shadow, between cool and warm tones.

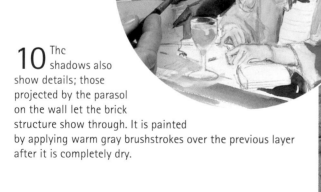

10 The shadows also show details; those projected by the parasol on the wall let the brick structure show through. It is painted by applying warm gray brushstrokes over the previous layer after it is completely dry.

11 Small details, such as the hair strands over the shoulders, are very important for the quality of the final results.

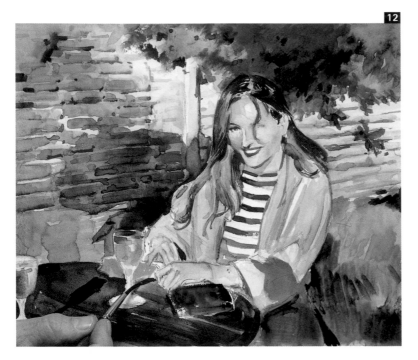

12 The red shadow on the table must be in sharp contrast with the light tones of the jacket to highlight it against the darker tonalities. This play of contrasts is typical of the classic watercolor.

13 The completed work is a magnificent example of how the classic technique can be applied to a theme including a figure. The numerous details in this composition are tied together by the strong drawing and a strong sense of tonal contrast.

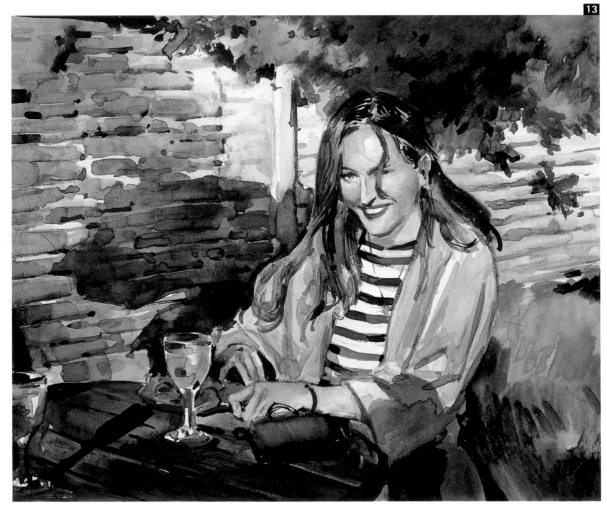

Reclining Figure

This exercise by David Sanmiguel is an example of the different possibilities that pastel colors offer in figure painting. A figure, which in this case is in a reclining position, is seen from an unusual perspective. The raised view makes the scene appear flat, almost without perspective. On the other hand, the body, covered with a soft, transparent veil, renders the tones of the skin visible.

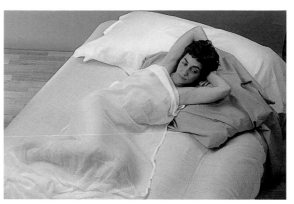

This woman lying in bed has her body covered with a cloth that is slightly transparent. This factor adds interest to the composition by introducing an unexpected texture.

2 The sketch allows the artist to check the proportions and the relationship between the dimensions and other factors, such as the inclination of the angles and the sizes of the different parts.

1 These lines make up the first sketch of the drawing. The figure and its surroundings are treated as one, and the lines of the diagram must take the entire composition into account.

MATERIALS
- Ivory color Canson paper
- Assortment of soft pastels
- Assortment of hard pastels
- Cotton rag

3 The figure is already visible and the drawing should not be elaborated any further, or the color would be too conditioned by the excessive precision of the lines.

TECHNIQUES USED
◆ Blocking in the figure ◆
◆ Blending ◆

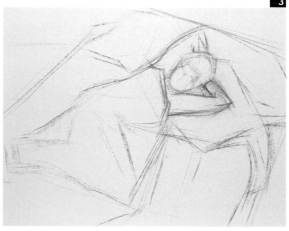

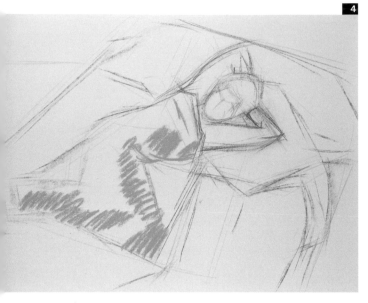

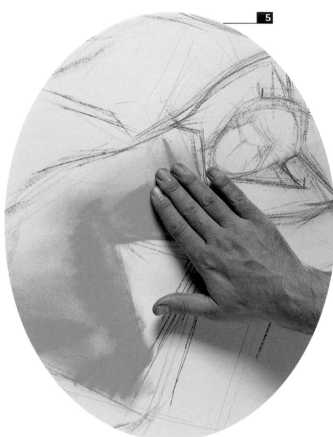

4 Color is applied with quick strokes that will later be blended with the fingers.

5 This is how the gray lines are blended; they will serve as the background color for the figure.

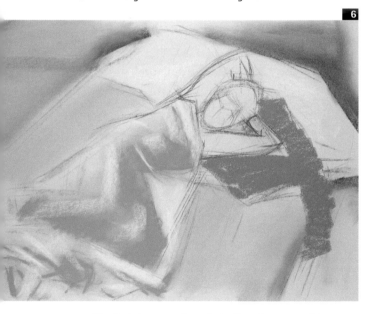

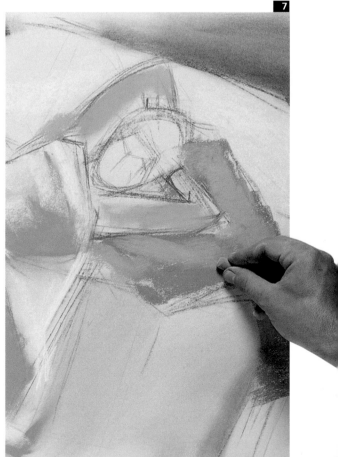

6 The first stage consists of shading the composition to evaluate the effect of the colors together. The same attention should be devoted to all the areas of the paper, without emphasizing any one of them in particular. This is the only way to maintain the overall harmony from the beginning of the process to the end.

7 Blending helps to spread the color and also to soften its intensity. To highlight the shadows, the same color can be used to draw some lines over the blended area, creating a more saturated tone.

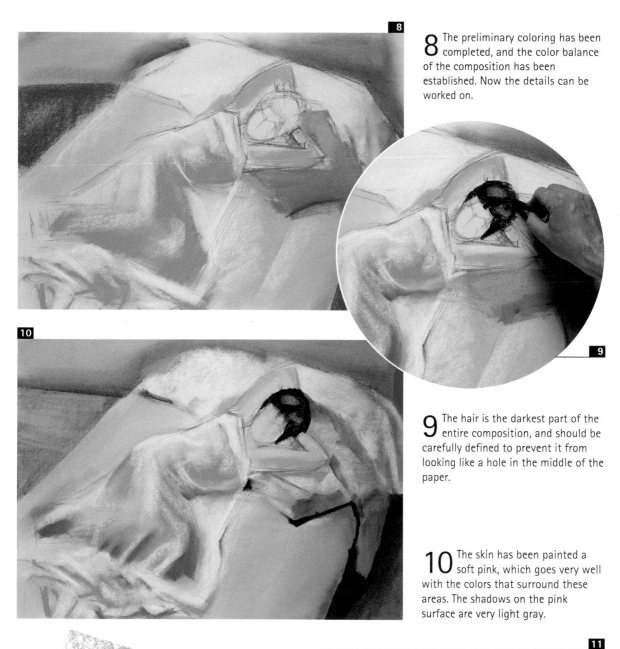

8 The preliminary coloring has been completed, and the color balance of the composition has been established. Now the details can be worked on.

9 The hair is the darkest part of the entire composition, and should be carefully defined to prevent it from looking like a hole in the middle of the paper.

10 The skin has been painted a soft pink, which goes very well with the colors that surround these areas. The shadows on the pink surface are very light gray.

COLOR DENSITY
Pastel colors can be applied in layers only if the underneath color is very thin, that is, if it contains very little pigment. Otherwise, the pigment of the bottom color will not allow the new one to properly adhere to the paper.

11 The applications of pastel colors cover the lines of the drawing and make them disappear. In some areas, however, it is a good idea to redraw the lines to highlight the details and the contrast between colors.

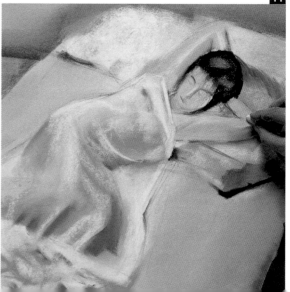

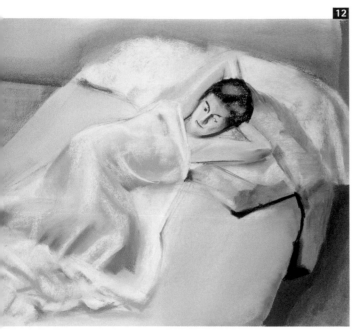

CONTRASTS

In a light color composition such as this one, it is important to introduce dark accents that add contrast and energy to the composition. In this exercise, those accents are provided by the hair and the facial features, which are the true focus of the composition.

12 The final touches are centered around the area of the head and the arms. The areas of light and shadow should be well defined for the facial expression to be as natural as possible.

13 Once the tones that define the volume of the face are applied, the work is considered finished. Here, the pastels have been used the traditional way to obtain harmonious and delicate results from the colors.

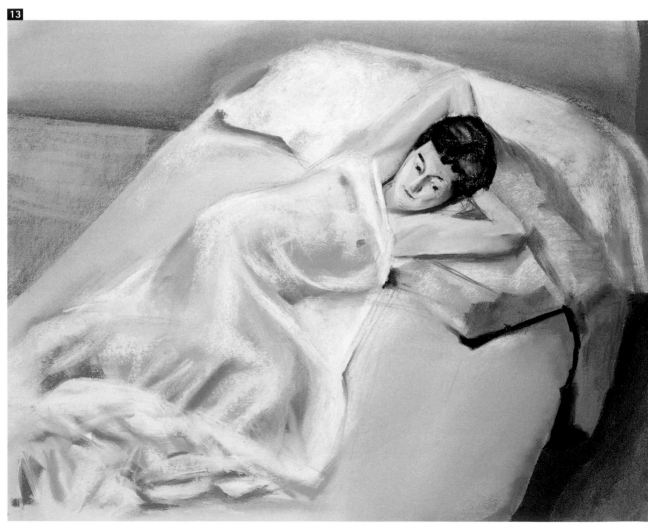

Figure in Oil in Chiaroscuro

Chiaroscuro is one of the traditional techniques in figure painting. Its origins date back to the Baroque period in the seventeenth century. Chiaroscuro requires a single light source that comes from within the composition. The chiaroscuro technique produces either very dramatic or very soft and intimate effects. In this exercise, Yvan Mas develops a theme in which the intimate and reflective mood give a special aura to the figure. Technically, the work is less complex than it appears to be, and should be approachable for any artist with a little experience.

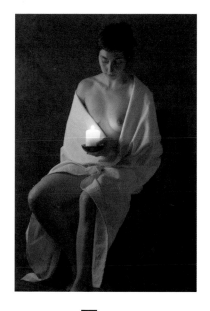

The private and intimate aura that surrounds the figure is the direct result of the special lighting, which provides a single source of light of low intensity and great warmth.

MATERIALS
• Stretched canvas
• Raw umber, burnt sienna, red, ivory black, yellow ocher, lemon cadmium yellow, titanium white, and ultramarine blue oil paints
• Two thin-bristle brushes and one medium

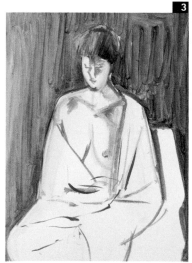

1 The first sketch is done with a brush and a few lines, which is enough to establish the size, proportion, and position of the body. The oval for the head is in perfect harmony with the composition.

2 Using the same burnt sienna color, the shadows that best define the volume of the figure are applied. The contours of the breasts and the basic folds of the blanket can be seen clearly.

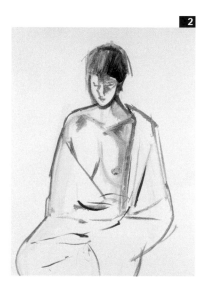

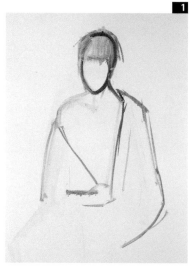

3 The background is very simple. Broad brushstrokes of black mixed with burnt umber, very diluted with mineral spirits, are applied avoiding the outline of the body. The basic contrast of the chiaroscuro has been established, although roughly and without details.

TECHNIQUES USED
♦ Blocking in the figure ♦
♦ Chiaroscuro ♦

SKETCH WITH OIL PAINTS

Most oil painters begin their work with a sketch drawn with the tip of the brush directly on the canvas. This type of sketch tends to be extremely simple, leaving ample room for corrections, but it establishes the general layout of the work from the very beginning. The brushstrokes are usually applied with a dark and warm color, diluted with abundant mineral spirits, so the brush easily glides over the canvas. This establishes a general, almost monochromatic background, where the variations in intensity suggest what will later become variations of color.

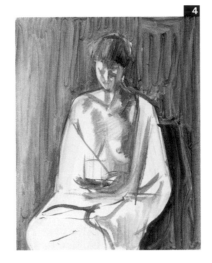

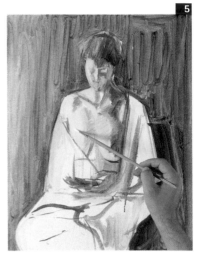

4 Now that the overall contrast has been created, it is a matter of applying the details. At the beginning the shadows and skin tones are applied without much regard for detail, so the distribution of light and shadows can be properly established.

5 The areas that until this moment were blocks of burnt sienna color are now defined with white paint, which is mixed with the sienna directly on the canvas, creating halftones, that is, medium tones that replicate the skin color.

6 The skin begins to acquire a pinkish tone, and the harsh contrast between light and dark colors is softened with the intermediate tones. The hand is a dark mass that stands out against the light background.

7 The modeling of the cloth must be worked at the same time as the volume of the body. Ocher tones have been added and excess brushstroke marks have been eliminated from the folds of the cloth.

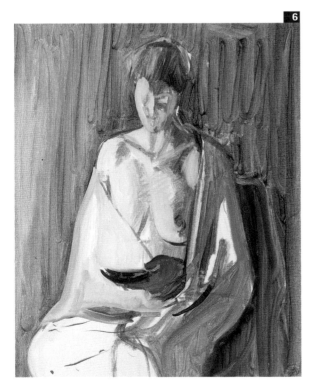

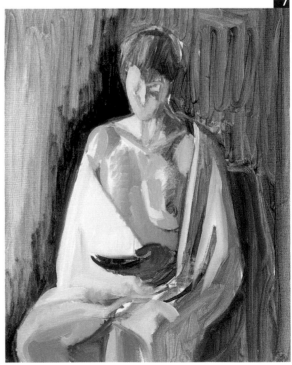

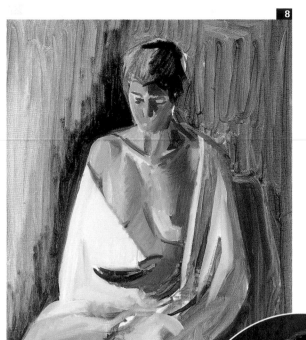

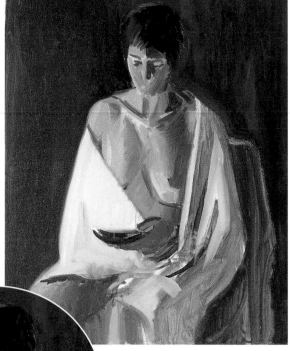

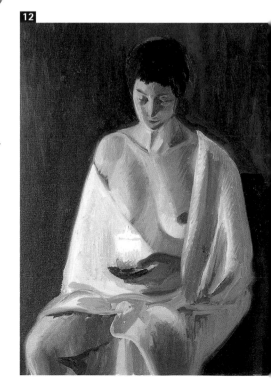

8 Now the attention is directed to the details of the head. Very detailed lines are added to define the hair as well as the basic facial features.

9 Brushstroke marks have been eliminated and a more consistent and opaque tone has been created, which gives new luminosity to the composition.

10 Now the head and the face are worked in more detail. The facial features, however, are established in a very simple manner, using light strokes of dark color over a head that has been properly defined with various skin tones.

11 The area of the candle has been left blank until the end, because it is an essential feature that creates the balance between light and shadow. It is nothing less than the focus of the painting, and all the rest of the values are determined based on it.

12 The skin tones have been softened and the work is almost finished. Now the composition has an overall color that is in perfect harmony with the soft light from the candle that bathes the figure.

MODELING AND CHIAROSCURO

Chiaroscuro usually implies elaborate modeling of figures, but in this case, the strong tonal contrast does not require excessive modeling. The skin is treated very delicately and halftones are predominant, providing an intimate mood to the scene and highlighting the relaxed atmosphere that dominates the work.

13 The fabric that hangs from the chair has been darkened until it nearly disappears into the background. The cloth is an important transition between the intermediate tones of the blanket that covers the figure and the nearly total darkness of the background.

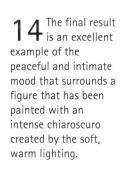

14 The final result is an excellent example of the peaceful and intimate mood that surrounds a figure that has been painted with an intense chiaroscuro created by the soft, warm lighting.

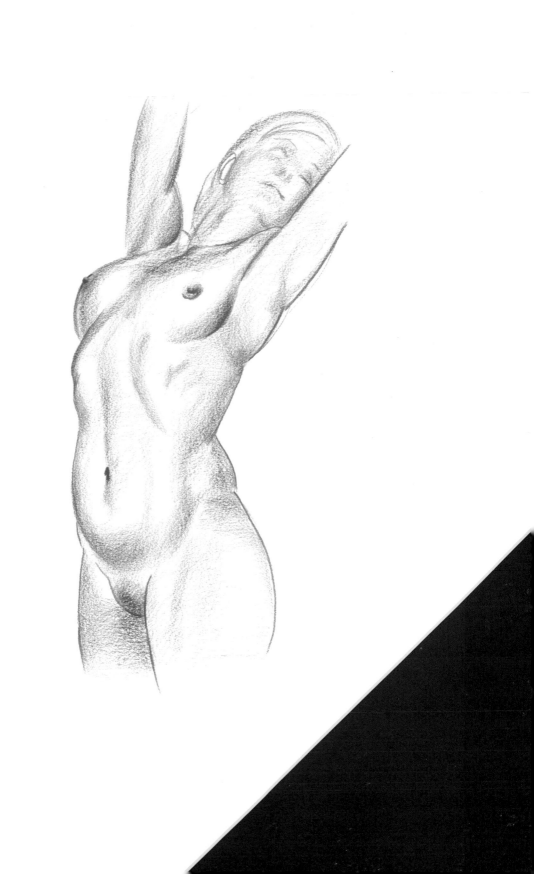

Other Books About the Human Figure
by the Publisher

If you wish to study the human figure in more
depth, you will find practical applications of
the techniques studied in this book in the
following titles by **Barron's:**

The Painter's Corner:
• *Anatomy for the Artist*
• *Heads and Portraits*

Art Handbooks:
• *Figures*
• *The Nude*
• *Human Figures in Movement*
• *Anatomy*